HIDDEN
HISTORY
of
CLEVELAND

Christopher Busta–Peck

THE
History
PRESS

Published by The History Press
Charleston, SC 29403
www.historypress.net

First published 2011
Second printing 2012
Third printing 2013
Fourth printing 2013

Manufactured in the United States

ISBN 978.1.60949.439.1

Busta-Peck, Christopher.
Hidden history of Cleveland / Christopher Busta-Peck.
p. cm.
Includes bibliographical references.
ISBN 978-1-60949-439-1
1. Cleveland (Ohio)--History. 2. Cleveland (Ohio)--Social conditions. I. Title.
F499.C657B87 2011
977.1'32--dc23
2011039787

CONTENTS

Acknowledgements 7
Introduction 9

Segue: Thomas Whelpley's Cleveland, 1833 11

PART I. EARLY HOMES AND SETTLERS
Identifying the Oldest Houses:
 Does Your Basement Look Like This? 15
Collinwood Farmhouses: The McIlrath Residences 18
Little House, Big House: 4216 East Ninety-third Street 19
Quarried on Site: The Rodolphus Edwards House 22
A Pennsylvania Tavern in Garfield Heights 25
Now We See It, Now We… 28
Once a House, Now a Ghost in the Central Neighborhood 29
Lakewood Farmhouse: The Isaac Warren Residence 31
For Generations and Generations, a House in a Landscape:
 4340 Turney Road, Cleveland, Ohio 36
The Last Pioneer House 42
Save This Greek Revival House! 43
Built Before the Civil War 45

Segue: Picturesque Cleveland, 1872 47

Contents

PART II. BUSINESS

The Dunham Tavern 51

Last of Their Generation:
 The Two Oldest Buildings in Downtown Cleveland 53

The Mechanics Block 55

Condemned: The Stanley Block 57

The House of a Shipbuilder 60

Garfield Savings Bank 62

Out of Place? 63

Segue: A Portrait of the City by a Young Artist—Cleveland in the 1870s 65

PART III. INDUSTRY

Hiding in Plain Sight: The Luster Tannery 71

The Fifty-Thousand-Ton Mesta Press Matters 74

Hulett Ore Unloaders in Action! 77

Cars, Beer and the Law 78

The Brown Hoist Building: An Industrial Landmark 81

The New Cuyahoga:
 A Proposal to Straighten the "Crooked River" 83

The Day-Glo House 84

Segue: Playing Catch on the Field Where Babe Ruth Hit His 500th Home Run 87

PART IV. SPORTS

The Largest Crowd for a Baseball Game:
 White Autos v. Omaha Luxus 89

The Pitch that Killed 91

The Jesse Owens House 92

The Birthplace of John W. Heisman 93

Segue: Snapshots of Cleveland, 1910 95

PART V. NOTABLE PEOPLE

James A. Garfield Slept Here 99

Breaking the Color Line: Charles W. Chesnutt 100

The William Howard Brett House 101

Langston Hughes: His Attic Apartment 102

Designing History 104

CONTENTS

Segue: Views of Cleveland, 1927 107

PART VI. NOTABLE BUILDINGS
The Schofield Building, Undressed 111
The Bare Bones of Severance Hall 113
The First Cleveland Clinic Building 115
Cleveland's Crystal Palace 116
Streamlined 118
Old House, Older House? 119

Segue: Ancient Fort, Newburg, Vanished 121

PART VII. LOST AND THREATENED
Threatened: The Euclid Avenue Church of God 123
The Last Act for Johnson's Cleveland Play House 125
Saving Only the Bell 126
The Prince Hall Masonic Lodge on East Fifty-fifth Street 128
Good Homes Make Good Neighborhoods 128
Charles Schweinfurth's Modest House 129
Troubling News 134

Notes 139
About the Author 143

Acknowledgements

When I began writing this section, I wanted to thank everyone who helped make this book what it is—there are so many people who ought to be named. I quickly realized that there was no way I could do this in a satisfactory manner; even if I went back through all of my notes, I'd miss half the people who deserved to be mentioned, and that didn't seem fair. Even then, this section of names would have filled at least three pages.

Instead, I offer a more general thanks. This book would not have been possible without the help of so many librarians, archivists and library professionals at institutions both public and private around the region. They helped me find the resources I needed and answered so many questions on short notice.

The readers of my blog, Cleveland Area History, deserve mention. They bring so many interesting stories to my attention that I would otherwise miss. When I need photographs on short notice, they are there to help. And when there were minor issues of fact in my posts, they brought them to my attention immediately.

Most of all, thanks is due to my family—my wife, son and daughter—for their patience while I've spent much of my time writing and researching.

Introduction

I created Cleveland Area History (www.clevelandareahistory.com) in the fall of 2009 as a way to share the materials I'd gathered and issues I'd discovered in the process of creating programs for a summer day camp at the Hough Branch of Cleveland Public Library, where I was the children's librarian.

The director of the day camp had asked if it would be possible to focus on African American history and culture—I obliged. At first, I got a lot of blank looks from the kids. When I talked about the people and events at Oberlin, forty miles to the southwest, I might as well have been talking about the other side of the country.

The next week, I planned to focus on two major writers who had lived in that neighborhood, Langston Hughes and Charles W. Chesnutt. The library has an excellent collection of photos of Chesnutt's house, which had been demolished in the 1940s, but I had nothing for Hughes. I set out to determine where he had lived. It was almost common knowledge that Hughes had lived in the neighborhood, but no one seemed to know where or even if the house was still standing.

I started with Arnold Rampersad's authoritative biography of Langston Hughes, which gave several addresses where Hughes had lived. Only two remained. After work, I went to photograph them.

For the day camps, I talked about their writings and about where they'd lived. I illustrated my talk with photographs of their houses. The response was extremely positive. I found that when I talked about people who had lived in their neighborhood—people who had walked the same streets they

walked every day—it was possible to make a real connection. There's a real value for strong visuals when teaching local history.

During the course of the summer, I also located the houses that Jesse Owens had lived in, including his residence from 1934 to 1936, when he won four gold medals at the Berlin Olympics, as well as broke three world records and tied a fourth at a Big Ten track meet in Michigan. This was the home of one of the ten greatest athletes of the twentieth century, at the peak of his career, *yet no one even knew it was there*!

I realized that there was a lot of interesting local history research to be done. Further, it could be done through books that could be sent to my neighborhood library and through the use of a variety of electronic resources—it didn't require spending a ton of time holed up in an archive, wearing white gloves and poring over dusty documents. Virtually all of the works cited in the text fit the above criteria—most are available online, primarily through the databases and resources of Cleveland Public Library and Google Books. The remainder can be sent to your local library branch for you to check out and take home.

I also realized, from the day camp, that to increase the demand for local history, I needed good imagery, preferably in color.

The response has been impressive. After two years, Cleveland Area History counts more than five hundred readers for each story, as well as more than three thousand followers on Facebook. I was told time and again that there simply wasn't the demand for local history in Greater Cleveland—I think I've shown otherwise. This is a selection of the best of the Cleveland Area History blog. If you like what you see here, there's always more at www.clevelandareahistory.com.

In 1834, Thomas Whelpley, an artist and surveyor, published a set of four engravings illustrating the Cleveland townscape. These are the earliest images of what Cleveland looked like, as a whole. (High-resolution scans are available online from the Cleveland Public Library.)

The population of Cleveland in 1830 was 1,075; Cuyahoga County was just above 10,000. The Erie Canal had opened nine years earlier, and the Ohio and Erie Canal had just been completed, dramatically reducing the cost of shipping to and from distant markets. Cleveland was booming and prosperous when Whelpley made these images—perhaps a reason that he felt that this portfolio might be commercially successful.

From Brooklyn Hill Looking East shows a town with a prospering waterfront. Many ships are docked along or are transiting the Cuyahoga River. While this is an area of bustling commercial activity, it is still rural—cows and sheep graze in the foreground.

From the Corner of Bank and St. Clair Streets Looking East illustrates some of the most notable buildings of the city at that time. Bank

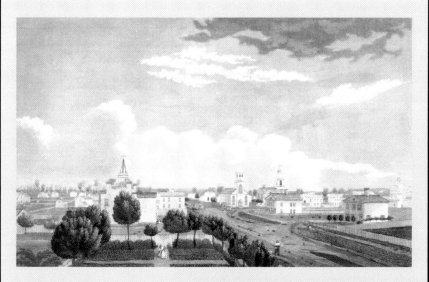

From the Corner of Bank and St. Clair Streets Looking East. A hand-colored engraving by Thomas Whelpley, 1834. *Courtesy of Special Collections, Cleveland Public Library.*

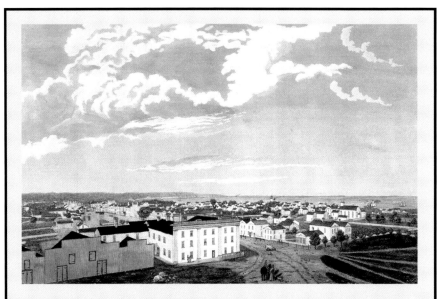

From the Court House Looking West. A hand-colored engraving by Thomas Whelpley, 1834. *Courtesy of Special Collections, Cleveland Public Library.*

Street is now West Sixth Street. About a third in from the left, the building with the tower is the Academy, the only school in Cleveland. It was built in 1821–22, replacing a small log structure that had been built a few years earlier. There are two churches: to the left, Trinity Church, built in 1828–29, and to the right, Presbyterian Church. At the far right, in the distance, is the second courthouse, built 1828.

The courthouse was located in the southeast quadrant of Public Square. In *From the Court House Looking West*, we can see Superior Avenue, the main business route. Even so, it has many residential structures, most built of wood. The newer homes have Greek Revival elements; the older have Federal traits. In the distance, to the right, we can Trinity Church.

From the Buffalo Road, East of the Court House looks west from about East Ninth Street (Erie Street, then) on the road we now know as Euclid Avenue. The road runs from the left corner toward the center of the image and the second courthouse, built in 1828. The courthouse was a gathering space, as well as the legal center. In the foreground, there is a large pasture, with cows grazing.

These images show a town that resembles a New England village. Animals still grazed near the center of the city, and the economy was

largely agricultural. Every building pictured here is gone. Even so, it's worth looking at the city as it was 177 years ago. Our streets still follow much of the layout present in these images. These prints can help to explain why our downtown is set up the way it is—a product of these early streets.

Part I

EARLY HOMES AND SETTLERS

IDENTIFYING THE OLDEST HOUSES: DOES YOUR BASEMENT LOOK LIKE THIS?

I've often been asked to help figure out the age of a house, usually from the people who live in it. While it is possible to learn quite a bit from historical records, this can require specialized knowledge and still leave one with only a range of dates. Homeowners (and residents) are in a unique position to help date a structure—they have full access to the house and can learn everything the structure has to tell.

The physical evidence in the house at 5856 Pearl Road, in Parma Heights, provides an excellent example of what we can learn. This historic home was photographed by Laura Howard about two and a half years ago, and she was kind enough to share her images.

The oldest part of the house, the southwest (left) wing, was probably built by Oliver Emerson in 1831. He was living on this site at the time. The date is the one given by the county auditor. The question is whether the date is accurate or if this house replaced the one present in 1831.

The exterior has been heavily modified. Other than the basic proportions, little original detail remains. The wood siding has been covered with asbestos shingles, window openings have been moved and dormers have been added to the center wing of the house. The location of the center window on the second floor is likely original, but beyond that, I can't be sure of much without physical investigation.

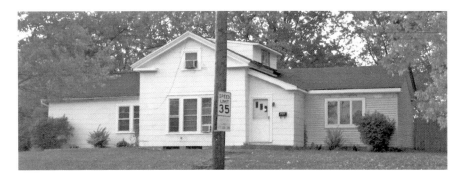

Farmhouse (circa 1830), 5856 Pearl Road, Parma Heights, Ohio. The oldest part is on the left. *Photograph by Laura Howard, 2009.*

The foundation appears to be made of material consistent with the 1830s but is concealed by a layer of mortar. There isn't a basement under this portion of the house, which is consistent with earlier construction. Inside, the north wall includes wood paneling, similar to the paneling in the front hall of the Dunham Tavern (1824, 1842; see "The Dunham Tavern"). The wide, thick floorboards, without subflooring, also tend to indicate an early date.

The house retains a central fireplace, but it appears to have been modified extensively. I suspect that underneath the current brick may be the original fireplace. The wall between the south and center parts of the house has been covered with drywall, concealing structural evidence. There are two openings on this wall. The door on the left, to the basement, is consistent in style with the middle third of the nineteenth century.

The doorframe shows horizontal white lines where the plaster spread through the lath. At the bottom, there is an area that is free of such markings, showing that the horizontal wood paneling once continued around the room.

The center part of the house reveals more detail. In the photo of the basement here, as well as in the lead photo, we can see hand-hewn timbers. Cutting lumber manually was incredibly labor-intensive, and sawmills were set up anywhere that there was sufficient waterpower to operate them. As a result, hand-hewn timbers are usually found only in the earliest houses here. Further, as this part of the structure is one of the most difficult elements to change, this can help us date a house even when much of the original detail is missing.

The stairs to the second floor reveal more structural details. We can also see a line on the wall, above the stairs, at a steeper angle than the stairs

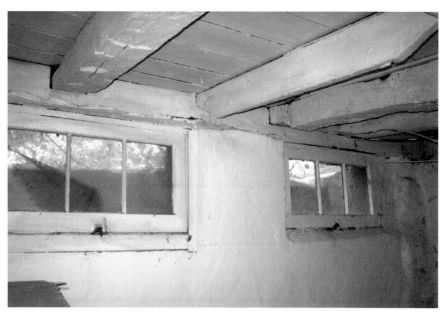

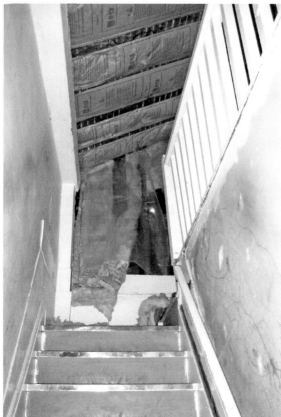

Above: Basement, Pearl Road farmhouse. Note the hand-hewn beams in the ceiling. *Photograph by Laura Howard, 2009.*

Left: Staircase, Pearl Road farmhouse. The beams that make up the structure can be seen along the edge, as can the former angle of the stairs, which was steeper. *Photograph by Laura Howard, 2009.*

currently have—the original angle of the staircase. The steeper diagonal lines are the original stringers (the structural boards that make up the sides of the stairs).

How old is this house? It's hard to say. Some part of the physical fabric dates to 1831, but how much?

COLLINWOOD FARMHOUSES: THE MCILRATH RESIDENCES

When I came across this house, at 15002 Sylvia Avenue, in Cleveland, Ohio, almost two years ago, I could tell that the style suggested a pre–Civil War construction date. The county auditor's records confirm this, listing the date as 1855, though it's possible that it was earlier.

I assumed that the structure had been moved, given that the street that it's on didn't exist at the time it was built. In fact, it's the location of the front door that has changed. On the side of the house, we can see two windows of proportions that one might expect of a house built between 1830 and 1860. The front doorway was originally located between these windows, facing what is now East 152nd Street.

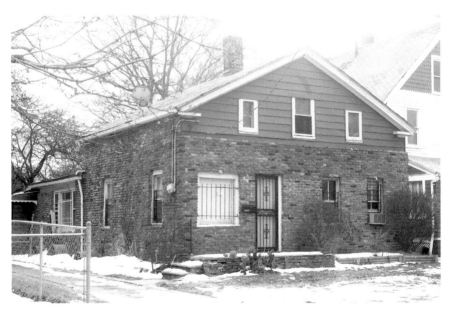

McIlrath residence (circa 1850), 15002 Sylvia Avenue, Cleveland, Ohio. It was constructed by the same builder as 15006 Westropp Avenue. *Photograph by the author, January 20, 2010.*

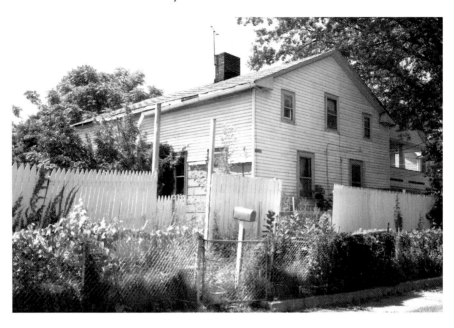

McIlrath residence (circa 1850), 15006 Westropp Avenue, Cleveland, Ohio. It was built by the same builder as 15002 Sylvia Avenue. *Photograph by the author, June 9, 2011.*

The facing brick makes it hard to tell what the side of the house that faces Sylvia Avenue might have looked like. I am reasonably sure that the placement of the second-floor windows is unchanged.

About a year ago, I came across 15006 Westropp Avenue. The proportions of the two houses are very similar. The likeness may be seen most obviously on the side of the structure facing the street, in the second-floor windows. I'm unsure as to the date of construction, but it was definitely before 1860.

At the time that these houses were built, the land was owned by members of the McIlrath family. This, and the similarity in style, strongly suggests the same builder. This makes the houses considerably more significant—while it's possible to identify similar works by a master builder, it's much more difficult to make connections between ordinary structures.

LITTLE HOUSE, BIG HOUSE: 4216 EAST NINETY-THIRD STREET

Small houses tend to either be demolished in favor of larger structures or remodeled and expanded until they no longer resemble the original

An early office (circa 1850), 4216 East Ninety-third Street, Cleveland, Ohio. This building, now a house, was moved to this site from Miles Avenue. *Photograph by the author, January 21, 2010.*

structures. Also, houses that are built on what become major roads are almost always replaced by commercial structures. For these reasons, I found it unusual for this diminutive, six-hundred-square-foot building to still be here. My first goal was to determine its age. As an example of the early built environment, I hoped that this was its original location. But Roy Larick (of Bluestone Heights, a website devoted to the historic landscape of northeast Ohio) pointed out that it was not included in the 1858 Hopkins *Map of Cuyahoga County*. This map is the first really accurate map of the area; it's useful because it shows every single house in the county. It, along with the other historic maps I cite, may be found on the Cleveland Public Library's website.

The 1881 *City Atlas of Cleveland, Ohio* is the next source for this area to show buildings in detail. The small structure on Miles on Lot 76 has disappeared, and a small building has appeared south of the rectangular one. On this map, Gaylord has become Woodland Hills and is oriented with east at the top.

I suspect that this small house was originally on Miles, as shown in the 1858 map, and was moved to the current location sometime before 1881. The owner of the lot remained the same, so it seems most likely that he would have moved the structure on his own lot. From its location, I

suspect that the structure was used as some sort of commercial building, perhaps as an office.

The 1892 *Atlas of Cuyahoga County and Cleveland, Ohio* reveals the owner of the property to be C.F. Christian. This provides a starting point for research.

The earliest record I've been able to find of this name is in the 1870 census, which lists a Chas Christian in Newburgh Township. Charles, a house carpenter, was born in New York in 1830. He had a wife, Lizzie (born 1830), and three children: Bertha (born 1854), Henry (born 1855) and Myra (born 1857). The 1880 census lists their address as 2617 Woodland Hills Avenue, which doesn't correspond to any residence that I can find.

The 1896 Sanborn Fire Insurance Map lists the larger house as 2030 Woodland Hills but doesn't give an address for the smaller building. The 1903 Sanborn map is the first source where I've seen it have its own address—2034 Woodland Hills.

After the streets were renumbered in 1905, the house became known as 4216 East Ninety-third Street. The larger house became known as number 4212. It is at this address that we find Charles F. Christian living in 1910. Two other families were renting space in the house at the time as well. Another family, John and Ada McGraw, were renting 4216 East Ninety-third Street. Charles F. Christian died in his house in 1919.

That's what we know from the historical record, bare facts with stories untold.

This little house was probably built between 1840 and 1850, though it could have been built a little earlier. It's one of very few remaining small, wood-framed structures in the city that are this old. I'd like to know more about what it looks like, but it is mostly hidden underneath the aluminum siding.

As it is, the only visible historical detail is the small three-pane window in the upper right in the photo. All of the second-floor windows would probably have been this design. This building reminds me of the Joshua Giddings law office (1823) in Jefferson, Ohio, though certainly the house was built later.

I almost missed a big part of this story: the larger house next door, 4212 East Ninety-third Street. Vinyl siding and the shape of the windows caused me to dismiss it initially—it struck me as built in the early twentieth century and remodeled recently. It wasn't until someone else suggested it that I considered the obvious: it was built in the 1850s or perhaps a little bit earlier. It's been on the maps since then.

I guess, based on the proportions, that there would have been four windows across the front of the first floor of the house and five across the second. It might have been of a similar style to the Spencer Warner residence (see "A Pennsylvania Tavern in Garfield Heights").

QUARRIED ON SITE:
THE RODOLPHUS EDWARDS HOUSE

I've driven by this house, at 10701 Buckeye Road in Cleveland, any number of times, without much notice. At thirty miles per hour, it looks like a late nineteenth-century house. I wondered if it might be earlier, but the proportions didn't seem right, particularly the pitch of the roof. I now realize that this is one of the most significant houses in the area.

At a slower pace, you can see the tool marks in the stone. You don't see this in later houses, once it was possible to mechanically smooth stone. There must have been a quarry nearby to supply the builders of this house enough material for both the wall and the main structure.

The aluminum-sided wing to the rear is probably newer than the sandstone wing. The small chimney suggests that the structure was a kitchen, added later.

The east side of the house shows evidence of a first-floor window, centered on the wall, that has since been filled. The dormers are a later addition. Galvanized finials on the dormers and the main roof are nice details. It's too bad that the first-floor windows have been filled in with glass block. The photograph of this house in Mary-Peale Schofield's *Landmark Architecture of*

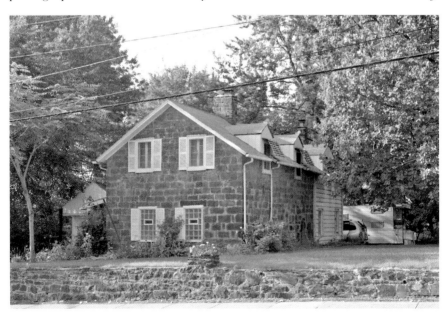

Rodolphus Edwards residence (circa 1845), 10701 Buckeye Road, Cleveland, Ohio. A farmhouse, built of stone quarried on site. *Photograph by the author, August 18, 2009.*

Cleveland (1976) shows the house with first-floor windows that match those on the second floor.

It's hard to figure out the original appearance of the west side of the house. It was probably the entrance—there is no evidence of an entrance on the other side or on the front.

The 1858 Hopkins *Map of Cuyahoga County, Ohio* should show the house. It indicates the property of an R. Edwards, 18.51 acres, at the northeast corner of the intersection of the two major roads, now Buckeye and Woodhill. The Edwards house should be near the east end of the lot and not the west end, as shown on the map. The 1874 *Atlas of Cuyahoga County, Ohio* shows the same property as the 1858 Hopkins map, still belonging to R. Edwards. The house is shown in the proper location.

Rodolphus Edwards's father had the same first name. To modestly confuse matters, father and son were not commonly referred to as Jr. and Sr. The father was one of the original surveyors of the Western Reserve. He built a very popular tavern and had considerable property holdings in the Greater Cleveland area.

The following is my best guess. In April 1836, Hanna and Starks Edwards (Rodolphus Jr.'s brother) transferred property to Rodolphus Edwards, parts of Lots 424, 425 and 426.[1] The 1858 map shows holdings by Rodolphus Edwards in Lots 425 and 426—this was the property transferred by Hanna and Starks.

Further, it seems likely that Rodolphus Jr. would have begun work on this residence shortly after acquiring title to the land. He would have been eighteen years old at the time.

The manner of the stone masonry provides further evidence of the date—it is more primitive than what I've seen in houses in the area from the 1850s. This narrows the date range. We can be sure that the house was built before about 1855 and reasonably confident before 1845. I want to say that it was built in 1836, but I would like more evidence, either physical or documentary.

Dating the Rodolphus Edwards house isn't made any easier by this excerpt from the *Annals of the Early Settlers Association*.[2] It states that Edwards was living in the old tavern:

> *Rodolphus Edwards, for short called "Dolph," and of whom I am about to write, can be numbered among the early pioneers of Cuyahoga county, having come here away back in 1797. He settled on a large tract of land now known as Woodland Hills, but formerly called Butternut Ridge. In addition to*

farming he kept a public inn or tavern, as they were called in those days, for the accommodation of the traveling public, which was a place of resort for the old pioneers who used occasionally to meet and over their glasses of cider-flip pass away the time recounting their trials and adventures of pioneer life. This old house is still standing, having been converted into a private residence, and is now occupied by Rodolphus Edwards, Jr., who himself is well advanced in years.

The tavern was at the corner of Woodhill and Buckeye, 0.4 miles west of the house. Perhaps the author was confused between the old tavern and this house.

I've tried to learn more about Rodolphus Edwards Jr., with little success. The *Annals of the Early Settlers Association*[3] provides the following memorial, which offers more information about his father than about him:

Rodolphus Edwards, whose death occurred at his home on Woodland Hills, on Thursday, August 21, 1890, was a son of Rodolphus Edwards. The latter was a member of the surveying party in the Western Reserve in 1798, in which year he arrived at Cleveland, together with Nathaniel Doan, wife, one son and three daughters, Samuel Dodge, father of the late Henry Dodge, Nathan Chapman, Stephen Gilbert and Joseph Landon. These eleven persons were the total permanent additions to the population of Cleveland during the year 1798. Mr. Edwards had followed surveying previous to coming here, and the compass used by him from 1792 to 1798 may be seen in the rooms of the Historical Society, to which it was donated by Mr. Edwards, recently deceased. Mr. Edwards, Sr., the first year he was in Cleveland built a log cabin "under the hill" at the foot of Superior street. He remained there, however, but a short time, and on account of the malaria at the mouth of the Cuyahoga, removed in a year or two, with two or three other families, to the high land running from Doan's Corners to Newburg…He was chairman of the first town meeting held in Cleveland, April 5, 1802, at the house of James Kingsbury. Mr. Edwards came here from Chenango county, New York, but the family is of Connecticut origin… Rodolphus, Jr., was born July 15, 1818…Rodolphus Edwards was a member of the Early Settlers' Association, and took great satisfaction in talking of the early days of Cleveland. He was well known in the ea'sterly part of the city, and had the respect and esteem of the community through a long and active life. His father bought a tract of land on what is now known as Woodland Hills, and kept a hotel there for many years. A large part of this property yet remains in the possession of the family, and here, on the old homestead, the son died, Thursday last, aged seventy-two years.

To help make sense of the Rodolphus Edwards house, I compared it to the John Honam residence, built about 1838. The latter is also known as the Oldest Stone House and is now a museum in Lakewood Park. It was originally located at 1369 St. Charles Avenue, Lakewood.

Both houses are about the same size, are made from the same materials and were built at about the same time. The windows on the front of the Honam house are not original, but the ones on the sides are.

The Historic American Buildings Survey (HABS) was a project created in 1933 to provide work for unemployed architects and photographers. It was charged with documenting our country's most significant buildings. The detailed drawings and photographs created as part of this project are all that remains for many of the structures.

HABS drawings suggest that the Honam house was originally three bays wide, giving it similar proportions to the Edwards house. The original floor plan of the Edwards house might well be similar to the one provided in the HABS drawings for the Honam house.

The most obvious difference between the two houses is the level and quality of detail. The Honam house has detailed gables, nicely trimmed, while the Edwards house has simple gables. The stones of the Honam residence were cut into smaller, more regular blocks, while for Edwards house they were rougher, with obvious tool marks.

There was a quarry close to the Honam residence, on what is now Cook Avenue, Lakewood, just a few hundred feet away. The stone for the Edwards residence was likely quarried right here on the site of the house.

This house is a critical piece of our local history. This house should be considered for status as a Cleveland Landmark and is a good candidate for the National Register of Historic Places.

A Pennsylvania Tavern in Garfield Heights

The Spencer Warner residence is a stone house located at 4678 Warner Road in Garfield Heights. It is also sometimes referred to as the Ceo house, after the family who occupied it for much of the twentieth century. A wing attached to the residence houses Ceo's Bar. One also sees it referred to as the Darius Warner homestead.

Spencer Warner was born in Connecticut in 1793[4] or 1797.[5] He married Sarah J. Collver, presumably before 1831—the year their first child was born.[6] Collver was born in 1801 in Canada.

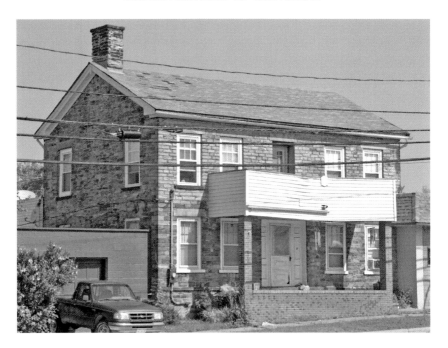

Spencer Warner residence (circa 1835), 4678 Warner Road, Garfield Heights, Ohio. *Photograph by the author, July 9, 2011.*

Spencer Warner purchased 164 acres—all of the Original Lot 479—from Caleb Goodwin, Levi Goodwin and Ward Woodbridge, executors of the estate of Horace B. Olmstead of Hartford, Connecticut, on April 17, 1820, for $400.[7] In 1834, the Warners purchased an additional 47 acres from William Archer and his wife, the western part of Original Lot 480.[8] This land was on a route that was already one of the major roads through the area. In the 1826 *Map of the Western Reserve*, the road, now known as Warner Road, is shown heading south-southwest from Newburgh. This location might well have been good for a business, situated at a prominent spot between Newburgh village and the Cuyahoga River.

The Warners had four children: Norman S. (born 1831), Marian J. (born 1833), Lydia Ann (born 1840) and John M. (born 1841).

Some have suggested that this grand house, well sited on a major road, was possibly a tavern or inn. While this seems quite reasonable, I've been unable to locate any evidence. The 1850 census lists Spencer Warner's occupation as a farmer. Norman Warner was working as a cooper at the time, while still residing on the Warner homestead.

Other sources note that the Warners were indeed farmers as the census indicates, with evidence of thriving business. The 1859 *Reports Made to the*

General Assembly and Governor of the State of Ohio notes that Spencer Warner was paid $0.45 for three dozen eggs, $0.18 for one dozen eggs, $8.10 for 81 pounds of sausage meat, $0.75 for five dozen eggs, $15.15 for 151½ pounds of ham, $10.55 for 52¾ pounds of butter, $3.60 for 120 bundles of oat straw and $10.50 for 300 bundles of wheat straw. This land would have made an excellent farm, with ready transportation to market, either locally or via the Ohio and Erie Canal. The slope of the land was gradual, and several streams ensured a supply of water for livestock.

By 1860, Norman had moved out of the house; Lydia was listed as a student and Miriam was resident with a husband—James Walker, a Scottish stonecutter—and child. Miriam and James Walker would live in the Warner residence for several decades. There are several other individuals with professions relating to stone quarries listed on adjacent pages of the 1860 census.

Sarah J. Warner died in 1864. She was buried at Harvard Grove Cemetery. Spencer Warner died two years later. He was buried in an adjacent grave, according to the *Cleveland Necrology File*.

As of 1870, Lydia Warner remained in the house built by her parents, as did James and Miriam; John M. Warner had moved out. The Walkers had two more children, Maggie (born 1862) and Ulysses (born 1865). The census lists two additional residents: James Bingham, a farm laborer from Ireland, and Sophia Gardner, a domestic servant from Baden, Germany.

James Walker died in 1897, Miriam in 1905 and Lydia in 1906, according to the *Cleveland Necrology File*. All were buried at Harvard Grove Cemetery.

Though some traditions indicate that the stone for the house was quarried from the area near Mill Creek Falls, it seems unlikely to me because it is almost three-fourths of a mile away. As Roy Larick indicated in *Western Reserve Stone House Locations*, early stone structures here were usually built because stone was readily available in the immediate area. It is more likely the stone came from an outcrop just to the west.

Adam Reiber and his family used the property as a residence in the 1890s. It seems that they rented the house, as I cannot find any record of transfer of the property.

The house was purchased in 1915 by Antonio and Pasqua Ceo, who operated it as a café and bar for many years. Pasqua and Antonio used the house as their personal residence as well, until their deaths in 1939 and 1958, respectively, according to the *Cleveland Necrology File*. It remained in their family until 2006.[9]

What do we know about the house itself? It has a different feel from the other pre-1860 stone buildings about which I have written (see "Quarried

on Site: The Rodolphus Edwards House" and "Hiding in Plain Sight: The Luster Tannery"). It feels, to my eyes, like something with more of a Pennsylvania influence.

The basic form of the house has remained the same over time. A stone ell that went off to the side, parallel to the road, was removed sometime between 1915 and 1950. During the same period, the second-floor window was turned into a door and a porch added. A chimney, at the opposite end of the house from the remaining one, was removed. While many of the windows are replacements, they are of the same form, six over six, as the originals. The original front doorway bears a slight resemblance to that of the Isaac Gillet house, built in 1821 by Jonathan Goldsmith in Painesville, Ohio, and now on display in the Cleveland Museum of Art. Remove its transom and outer columns and replace the leaded glass with standard panes, and you have something that looks very close to the doorway in the Warner house, as illustrated in historic photographs.

How old is the house? We know that the house was built between 1820 and 1860. Further, we know that Warner was living on this site in 1820—we just don't know whether it was in this structure or in an earlier house that this one replaced. A house of this size and quality represents a significant investment of labor and time. How early might Warner have been able to assemble the resources while devoting his energy to clearing and improving his land?

The quality of the stonework is more refined than in the Honam or Edwards residences. The tool marks, however, are rougher, suggesting earlier and more primitive instruments used in the quarrying.

The pitch of the roof is closest to the Honam residence, suggesting an earlier date of construction. The style overall would lead me in that direction as well. We can say that it appears earlier than many of the buildings discussed previously.

This is an interesting and historically significant structure. It represents the efforts of an early farmer to make a place for himself within his community. The house, on a prominent transportation route, is evocative of both our agricultural and early industrial heritage.

Now We See It, Now We…

The Brainard residence is a small house, built about 1840, at 4107 Denison Avenue in Cleveland. It is going to be demolished soon. It is one of very few surviving houses of this age and style left in the city. It is similar, in some

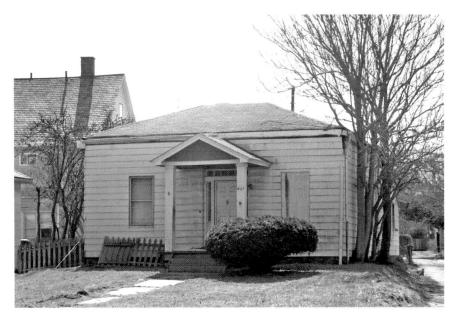

The Brainard residence (circa 1840), 4107 Denison Avenue, Cleveland, Ohio. Demolished. *Photograph by the author, March 31, 2010.*

ways, to the Leonard Case residence (see "The Last Pioneer House") and the H. Mould residence at 2637 Cedar Avenue (circa 1840), both documented by the Historic American Buildings Survey and both now lost.

Many of the architectural details have been hidden by time and remodeling. The sidelights and transom surrounding the front door retain some obvious detail. It is similar in style to the front door of the Isaac Warren residence.

It's a small house. While it does require some major work, it's on a scale that's small enough that it could be fixed. It's not like one of the mansions in Wade Park or East Cleveland that could easily become epic, insurmountable challenges.

Why can't it be saved?

Note: Soon after I wrote this, the house was demolished.

Once a House, Now a Ghost in the Central Neighborhood

I often browse the local real estate listings in search of interesting historic properties. This house, at 2208 East Thirty-sixth Street, caught my attention recently. According to the listing, it was built in 1860. With all of the

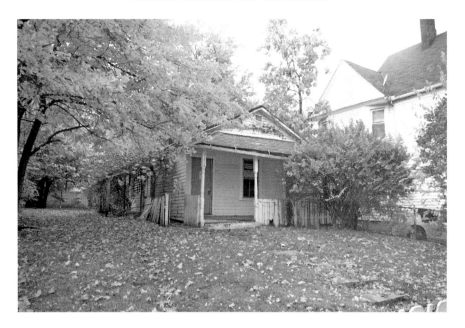

Single-story house (circa 1860), 2208 East Thirty-sixth Street, Cleveland, Ohio. Demolished. *Photograph by the author, October 30, 2009.*

redevelopment in the Central neighborhood of Cleveland, this would make the house one of the oldest in the neighborhood—I had to investigate.

Cuyahoga County offers some of the best access to real estate records anywhere. So that's where to start researching a house. But while the county auditor provides a considerable amount of information about each property and piece of land, the provided dates for houses are often incorrect—and just about everything built before the twentieth century is dated as "1900." But when a house *is* given a date before 1900, it's often correct or at least close. In this case, the auditor agrees with the date of 1860.

The next step is to trace back the ownership of the house, using information from the office of the county recorder, which provides online access to property records dating back to 1811. By tracing the transfer history, you can often get good clues to when a house was built.

And then, of course, you look at the house. A visit confirms that the house does, in fact, appear to have been built about 1860. The one next door, according to the auditor, was built in 1880. I don't feel completely confident in that date, due to the similarities in shape and style—they could have been built by the same builder. But the pitch of the roof on 2212 East Thirty-sixth is a bit greater, and the house is sited closer to the street, which supports 1880.

Architecturally, it isn't especially impressive. The interior has that lovely 1970s faux wood paneling. It's small, at 795 square feet. As an example of what a large part of Cleveland used to look like, it is significant. Due to the small size of the house and simplicity of the roof, it wouldn't be a terribly expensive house to rehabilitate, even though it clearly needs quite a bit of work.

These were my impressions during my site visit, but by June 2011, the house had been demolished.

LAKEWOOD FARMHOUSE: THE ISAAC WARREN RESIDENCE

I was browsing through the Historic American Buildings Survey (HABS) photographs and documentation for Cuyahoga County and found three houses that were documented in Lakewood. Two of them, the Nicholson house (1839) and the John Honam house (1834)—more often known simply as the Old Stone House—are still standing and are familiar Lakewood landmarks. The third, however, I did not recognize.

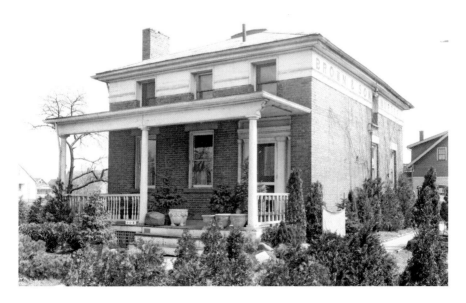

The Isaac Warren house (circa 1830), 2281 Warren Road, Lakewood, Ohio. Demolished. Photograph by Carl Waite for the Historic American Buildings Survey, April 28, 1936. *Courtesy of the Library of Congress.*

According to the HABS documentation, the Warren house was located in Lakewood at the intersection of Warren and Fisher Roads. There is no Fisher Road in Lakewood at present.

I looked in the 1914 *Plat Book of Cuyahoga County* and found that Fisher Road is now known as Lakewood Heights Boulevard. Further, it shows a brick, one-and-a-half-story house on the northeast corner of the intersection with Warren. A 1929 Sanborn Fire Insurance Map confirms that the building on the northeast corner of the intersection is the Warren house. The distinctive footprint of the house exactly matches the footprint in HABS documentation.

I wanted to know more about the house and its inhabitants. I contacted Mazie Adams, director of the Lakewood Historical Society, and she provided valuable research, including many sources that I would not have otherwise been able to check.

Isaac Warren settled in Rockport Township in 1822, according to the sources for virtually all of the biographical information on the Warren family.[10] Lakewood is located in the northeast corner of what was once Rockport Township. The sources note that Warren was a stockholder or investor in the Connecticut Land Company. I doubt that he was an "original stockholder," as there is no mention of his name in the index to Claude L. Shepard's *The Connecticut Land Company: A Study in the Beginnings of the Colonization of the Western Reserve.*

It is more likely that he settled here in 1824, the year Warren Road was created, following in part an old Indian trail between Detroit Avenue and Lorain Avenue, according to *Early Days of Lakewood.* In 1824, he purchased land from Garrit and Sarah Smith of Watertown, Connecticut.[11]

Mrs. Townsend's Scrap Book provides the most complete account of his family:

> *They came overland from New Bedford, Connecticut. Mrs. Warren was Amelia Bronsen* [Bronson] *before her marriage, and had a great local reputation as an expert spinner of wool and weaver of homespun, which was the only cloth obtainable in those days. It was in fact "all wool and a yard wide." Mrs. Warren was born in Connecticut in 1799. Isaac Warren was a descendant of Dr. Joseph Warren of Boston who was killed in the Revolutionary War at the battle of Bunker Hill. Isaac Warren was a prominent citizen of the pioneer days and one of the biggest land owners, having several hundred acres. Mrs. Phelps is his only descendant living in Lakewood now. She lives on Clifton Boulevard with her daughter. Her son is married.*

There were seven children born to the Warren Family; Sabra and Rebecca, daughters; John, Lucius, Abraham, Isaac and Sherman, sons. Lucius, Abraham and Isaac moved to Iowa and became large property owners. Sherman Warren settled in Missouri. Sabra married, Silas Gleason, son of pioneer Jeremiah Gleason, and Rebecca became the wife of John Johnson.

The only daughter of Rebecca, who for many years was regarded as mentally unbalanced due to a siege of scarlet fever, fell heir to all the Warren acreage. She was finally judged sane and left her estate to the Warren family, after giving a large slice to a German housekeeper who had cared for her in her last days.

There's a problem with this account, which is repeated in other sources: the claim that Isaac Warren was the descendant of Dr. Joseph Warren. The 1860 census records Isaac Warren's birth in 1782, seven years after the Battle of Bunker Hill. Also, both of Dr. Warren's sons died in their early twenties, leaving no heirs.

The 1830, 1840, 1850 and 1860 censuses place Isaac Warren in Rockport Township. He is listed as the property owner for part of the land (though not the site of this house) on the 1852 Blackmore and 1858 Hopkins maps. I have been unable to find any further records—particularly, any property transfers that might suggest the dispersal of his estate or conveyance to his heirs. But by 1874, the property was no longer in his hands; the *Atlas of Cuyahoga County, Ohio*, published that year, shows his land split up between different owners. Who was Isaac Warren? We can guess that he was a reasonably prosperous farmer, judging by his landholdings and his house. He owned, at one point, at least 140 acres.

The HABS records provide photographs and detailed architectural drawings of the house. These include exterior views, details of moldings and the front door and floor plans for the first and second floors.

A detail view shows the exterior of the house as it appeared before the addition of a porch. The bricks were probably a raw sienna or ochre—the color of the clay in the immediate vicinity. This is consistent with the Price French residence, built in 1828 at the southwest corner of Detroit and Wyandotte. The French residence was noted to have been made from "mustard-colored" bricks.[12] The window sills were cement, and the lintels were stone. The sloping part of the roof was slate, while the (nearly) flat part was tin.

HABS chose to document the house because it was one of the oldest houses in Lakewood. The survey estimated the date of construction as 1835,

though it is noted that "[l]ocal historians and early owners are unable to shed much light on who the original owners and builders are." A similar assessment is made in *Early History of Lakewood*. The survey's notes state that the walls were thirteen inches thick, consistent with the 1830s.

The front door is similar to though more ornate than the front door of the Brainard residence (circa 1840, now demolished). By the time it was documented by HABS, the sidelights and transom surrounding the front door had been filled in.

Each floor of the Warren residence was about seven hundred square feet. Entering the house through the front door, you were greeted by a hallway with a set of stairs on the right going up to the second floor. The parlor, which measured about thirteen by fifteen feet, centered on a large fireplace, the source of heat in the house. A large open doorway joined the parlor to the dining room. The dining room, about fourteen by sixteen feet, provided plenty of space for the Warren family and any guests or farm laborers. The ceilings on the first floor were eight feet, eight inches high.

The second floor had somewhat lower ceilings—seven feet, three inches at the highest point. The stairs from the first floor led to a hallway with four doors. Three opened to bedrooms. The fourth opened to a winding staircase that led to a small loft. The loft was a cramped space—about four feet at the highest point.

So when was the house built? It is shown on the 1858 Hopkins *Map of Cuyahoga County* on a forty-four-acre parcel owned by J. Johnson. However, the map also illustrates a house on a larger parcel of land still owned by I. Warren. That house was located east of Warren Road, slightly south of where Westland Avenue now runs.

We know that Isaac Warren built a house when he first moved to Rockport Township and that this one was built later. Could the house owned by Isaac Warren in 1858 have been the first house he built here? The 1830 census shows seven people in the Isaac Warren family. The 1840 census shows nine. By 1850, the number was reduced to three. I suspect that the house was built in about 1835, as has been suggested, as the family was growing and needed more space. Another possibility is that it was built in the 1840s. The site of the house and about twenty-five acres of land were transferred from Isaac Warren to his son, John B. Warren, in 1840.[13] John Warren does not appear in the 1840 census, yet by 1850, his family had grown to seven members. The house might have been built by him.

In 1850, John and Ann Warren and four children (Catharine, Martha, Mary and Lucy) were living in this house, as well as John's brother, Lucius. Isaac Warren lived until after 1860, and Amelia Warren, his wife, died sometime before 1850, according to the 1860 and 1850 censuses, respectively.

Rebecca Warren married John H. Johnson, a freshwater sailor born in New York, sometime before 1850.[14] In 1853, he purchased this house and forty-four acres of land, north and east of the intersection of Warren Road and Lakewood Heights Boulevard, from John B. Warren and Ann Eliza Warren.[15] This ownership is shown in the 1858 Hopkins map. He worked the land as a farmer, according to the 1870 census. John and Rebecca had one child, Henrietta, born about 1860.

Johnson is not mentioned in the chapter of *Early Days of Lakewood* titled "Late Pioneers, 1840–1865" nor in the 1865–89 chapter. HABS documentation provides some notes, according to oral history: "Mr. Johnson's folks resided on Johnson Street, also known as Water Street in Cleveland, Ohio." By 1874, their holdings had increased to more than sixty acres, as shown on the *Atlas of Cuyahoga County, Ohio*. At least some of this increase was due to the dispersal of Isaac Warren's estate. It's worth noting that on this map—as well as on maps published in 1892, 1898 and 1903—that Rebecca P. Johnson is listed as the owner of the property, not John H. Johnson.

Rebecca Johnson died between 1870 and 1880, based on censuses for those years. It is curious, then, that she is listed on the maps as the owner of the land. Perhaps her estate was the owner—a 1904 property sale lists Henrietta as the sole heir of Rebecca Johnson.[16] John H. Johnson died in the residence in 1905, according to the *Cleveland Necrology File*.

Henrietta Johnson remained in the Isaac Warren residence for the rest of her life, as noted by the 1880 and 1900 censuses. In the early twentieth century, the parcels of land around the house were gradually sold, as shown in the 1914 *Plat Book of Cuyahoga County*. She died in the Warren residence in 1917. After Henrietta Johnson's death, I found ownership impossible to follow. This is due to the rapid split of parcels in the area into residential lots and the frequent transfer of property via foreclosure in the early 1930s. My only evidence from this period is the HABS photo with a sign for the Brown & Son nursery painted on the side of the house.

The property was sold at a sheriff's sale in 1936 to Bertha H. Gund.[17] In 1938, John J. Gund and Bertha H. Gund sold the property to Field, Richards and Shepard, Inc.[18] The property transfer included an interesting provision:

Excepting, however, and reserving to the Grantor the brick house and wooden shed now on said premises (but not the land on which they are situated), together with the right to enter upon said premises and remove said house and shed at any time within thirty days from and after the date

hereof; provided, however, that if said house and shed are not removed from said premises within said thirty day period, title thereto shall pass to and vest in the Grantee.

The transfer provision makes me wonder if the house was moved. Mazie Adams checked the permits at city hall but was unable to locate either a demolition or moving permit.

Later in 1938, Field, Richards and Shepard, Inc. sold the property to the Standard Oil Company.[19] Soon after, a gas station, Meme's Sohio, was built on the site. The property is now a car rental agency.

FOR GENERATIONS AND GENERATIONS, A HOUSE IN A LANDSCAPE: 4340 TURNEY ROAD, CLEVELAND, OHIO

On November 10, 1814, Noble Bates contracted with Aaron Olmsted to purchase Lot 472 in Newburgh Township and then, in 1833, actually purchased the land from Levi Goodwin and Ward Woodbridge, the trustees

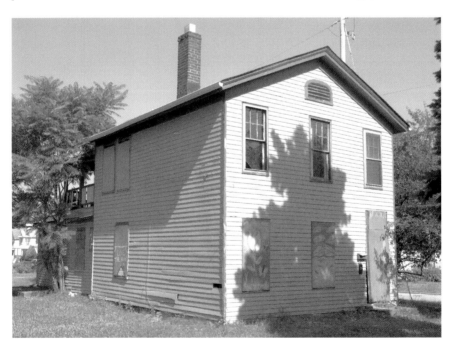

An early house (circa 1835), 4340 Turney Road, Cleveland, Ohio. *Photograph by the author, July 9, 2011.*

of Aaron Olmsted, for $550.[20] This is the land on which this house was built. It offered a good site for a house on a major road. In 1826, Turney Road, then known as the road between Newburgh and Tinker's Creek, was one of but a dozen roads in the county that were noted on Sumner's *Map of the Western Reserve.*

Noble Bates and Aurilla Boot Bates came to Newburgh Township from Essex, Vermont, in 1812. They had four daughters—two born in Vermont and two in Ohio. Bates's livelihood was tied to his location adjacent to Mill Creek, as he ran a mill, grinding grain into flour. He also operated the Bates Tavern in Newburgh from at least 1820 to 1830, as noted in *Historic Sites of Cleveland.* Both served as community gathering places. *Pioneer Families of Cleveland, 1796–1840* sums up the lives of the four Bates daughters:

> *Sophia Bates married Barnabas Laughton in 1830 and went to Chicago. Five years later, she returned a widow with two sons. Afterward she married Albert Kingsbury, and had one daughter. After Kingsbury's death, she married Thomas Garfield, uncle of the [future] president, and another son was added to her children. Sophia Bates Garfield was energetic and jolly.*
>
> *Elvira Bates married Stephen V.R. Forbes of Chicago.*
>
> *Lucy Bates married Benjamin Wiggins of Newburgh, and had one daughter and two sons.*
>
> *Eunice Bates married Eben Miles, eldest son of Theodore and Lydia Clark Miles. She had two sons and two daughters.*

Just across the road from the Bates parcel, on a hill overlooking Mill Creek, was a farm where a bounty of wild fruits and berries grew. It was the home of Nathaniel Wiggins and Phebe Dodge Wiggins, who had brought their six children to Cleveland from Montpelier, Vermont, in 1820. A son, Benjamin Wiggins, married Lucy Bates, according to *Pioneer Families of Cleveland.*

In 1835, Noble Bates sold most of Lot 472, excepting twenty-eight acres from the southeast corner, to Benjamin L. Wiggins, his son-in-law, for $1,200.[21] Wiggins would have been quite familiar with the land, having grown up close by. The higher price per acre listed for the Bates-Wiggins transfer strongly suggests that it had recently been improved in some significant way—most likely by the construction of a house.

Benjamin Wiggins also had twenty-five acres on Turney Road that he had purchased from Isaac Weigs in 1831 for $125.[22] In the intervening years, it appears that he built a house on that land. It was located on the east side of the road, between Rosewood and Cardwell Avenues. Benjamin is said to

have sold tinware and Seth Thomas clocks before becoming a farmer. He died in July 1864. Lucy survived him by four years, until May 1868.[23]

On the same day it was given to them, Benjamin and Lucy Wiggins sold their part of Lot 472 to Zacharais Eddy for $2,000, which was $800 more than he had paid.[24] Eddy took out a mortgage with Noble Bates to pay for the property. We can guess that Bates sold the property to Wiggins at a reduced price as a wedding gift. This higher price suggests even more strongly that a house was already present.

A year later, Zacharias Eddy left Newburgh for Brooklyn Township. He sold the land to Lewis Short (also known as Peter Lewis Short, or Peter L. Short) for $2,500.[25] Three years following, Peter L. Short and Ellen Short sold the property—all of Lot 472 excepting twenty-eight acres in the southeast corner—to Thomas Garfield, a farmer, for $1,250.[26]

Sophia Bates and Thomas Garfield married on November 10, 1850. With this union, the land came back into the Bates family. Given Garfield's other landholdings, he probably already had a house (see "James A. Garfield Slept Here"). Alternately, the house may not have been standing at the time of the transfer to Thomas Garfield—it was not unusual for houses to burn down—and perhaps this was the reason for the diminished value of the property.

In the spring of 1854, for the sum of $213, the Garfields sold 0.6 acres to H.M. Miller.[27] The next month, Miller took out a mortgage with Garfield to pay for the lot.[28] This property is in the northeast corner of the section.

This was the first time that the parcel on which the house sat at 4340 Turney Road was separated from the larger lot. The house may have been built by H.M. (or H.W.) Miller, about whom, unfortunately, I have been unable to learn anything else. Further, I have been unable to locate when Miller might have sold the house to the next owners, the Browns.

In 1855, the Northern Ohio Lunatic Asylum (later known as the Cleveland State Hospital) was completed on the opposite side of the road. It was built on land donated by the Garfield family.

James H. Brown and Elizabeth Brown were both born in England, in about 1820 and 1823, respectively. They immigrated to Canada, where they had a child, Louisa, in 1860, according to the 1870 census. Sometime before 1870, they moved to Newburgh.

James H. Brown was a carpenter and joiner. It's possible that he built the house, if the property was transferred to him relatively shortly after Miller became owner. It's also possible that he did a major renovation on an existing structure.

Regardless of the builder, this is not the sort of house that we expect to find on a farm. Rather, it looks like a house built in town. In the 1850s,

the area in the center of Newburgh was built up and there were plenty of houses along Warner Road, but Turney remained less densely populated. After a fire in 1872, a massive new complex was built for Cleveland State Hospital. The Victorian stone edifice loomed over the neighborhood for the next hundred years.

The Browns sold this 0.75-acre parcel to Carrie L. Salisbury, wife of Vial Salisbury, in April 1874 for $3,800.[29] The Salisburys had moved here from Bedford. By this time, Thomas Garfield's farm had been split into residential parcels.

Vial Salisbury was born in Ohio in 1843, in the village of Warrensville, to Alson A. Salisbury and Betsy B. Salisbury, both of whom had come to Ohio from New York. Alson was a millwright. Vial's oldest brother, Vincent, ran a tavern on adjacent property. The next oldest, Hiram, was a blacksmith.[30] In July 1861, Vial enlisted as a bugler, Ninth Independent Battery, Ohio Volunteer Light Infantry. Caroline Ward was born in Pennsylvania in about 1845 to Joseph and Emeline Wood. A few years later, the family moved to Bedford Township, where they purchased a farm of about eighty-three acres, located south of the village.

Shortly after his return from the war, Vial Salisbury and Carrie Ward were married. They had four children: William (born 1866); Alson (born 1869); Joseph (born 1876) and Emma (born 1878). Vial was a painter for the state hospital beginning in 1876.[31] He remained in its employ for the rest of the following year, with an annual salary of $300.[32]

The farmhouse had reached its current shape, with minor exceptions, by 1881. The property also had a barn of a decent size—perhaps seven hundred square feet—as well as a small shed.

The Salisburys witnessed the growth of this area from rural and agricultural to densely populated and industrial. In 1894, the Salisburys sold off the west end of the lot for $250.[33]

Vial Salisbury died between 1894 and 1903 (probably before 1900). Carrie L. Salisbury sold the house and property to Julius E. Stewart in July 1903 for $1,500.[34] Stewart immediately sold the property to Lorenzo F. McGrath at the same price.[35]

Progressive Men of Northern Ohio, published in 1906, describes McGrath:

> *Lorenzo F. McGrath, Cleveland. Beckwith & McGrath. Born Big Island Township, Marion Co., Ohio, Nov. 28, 1871. Teacher in public schools from 1888 to 1891. Admitted to the Bar June, 1894. Began the practice of law in Cleveland same year and later in the firm of McGrath & Stern.*

Assisted in the organization of and became interested in several coal and railroad enterprises in West Virginia. President of Cleveland & West Virginia Coal Co.; Director The Cecil Coal & Coke Co.; Director The Valley Fork Coal Co.; Director The S.W. Burrows Co.; Vice-President The West Virginia Securities Co.; Member the Cleveland Chamber of Commerce; Member Clifton Club.

It seems unlikely that McGrath bought the house for his residence—it must have been an investment or rental property. Five years later, in 1908, he sold the house to Catherine J. Flueck for $1,650.[36]

August J. Flueck was born about 1862 in Ohio, the son of German immigrants. He was a machinist in the steel mills. He married Catherine J. Schmitt, who was born about 1865, also the child of German immigrants, according to the 1910 census. They had three daughters: Frances M. (born about 1897), Catherine A. (born about 1901) and Alexandra T. (born about 1906).[37] The ownership of the house remained in one of their hands for almost seventy years.

The Fluecks had moved into the house next door, 4346 Turney, sometime before 1910. It was owned by Catherine's family. It was a smaller house, so their move to it suggests either economic need or strong financial incentive to rent the other property.[38]

As of 1910, 4340 Turney was being rented by two families, suggesting that it had been split up into a duplex. One family was that of Gustav W.C. Trende, a wire drawer in a wire mill, and Katherine Trende. At the time, they had six children: Arthur (seventeen), Nicholas (sixteen), Frank A. (fourteen), Florence (twelve), Carl M. (three) and Walter J. (nine months). Two were employed in industry—Arthur as a teamster and Nicholas as a plater in a chain works.

The other family living at 4340 Turney in 1910 was that of Gregory Gonder, Theresa Gonder and their son, Martin G. Gonder. Martin was employed as a machinist in the chain works and his father as a helper there. Theresa Schmitt sold the Fluecks the house at 4346 Turney in 1915,[39] so then they owned both houses. I found no record of August Flueck's death, but by 1920, Catherine Flueck is listed as a widow. All three daughters were still living with her. Frances and Catherine A. were both working as stenographers, in a hardware store and chair factory.

In 1920, the residents of 4340 Turney were Elizabeth Crago, a widow, and the Bennet family. John Bennet, an English bricklayer, had come to America in 1883, becoming a U.S. citizen in 1896. He and his wife,

Lena, had seven children: Charles (twenty-three), John (nineteen), Fred (seventeen), Myrtle (fourteen), George (twelve), Gladys (eight) and Lucille (three). Charles worked as a machinist in a steel mill, while John and Fred both were employed in a print shop.

I have been unable to locate 1930 census records for the Fluecks or for the residents of 4340 Turney. The Bennet family had left the house by this time, for a residence on East Ninety-fifth Street.

Catherine J. Flueck died in 1946, according to the *Cleveland Necrology File*. The house then transferred to her three daughters,[40] who, in turn, transferred it to Catherine A. Flueck, the older of the two who remained single. Catherine A. and Alexandra T. remained residents of 4346 Turney.[41] Catherine A. Flueck died in 1963. The house then transferred to Alexandra T. Flueck, who remained there.[42]

The state hospital was closed in the early 1970s, and the main building was demolished soon after.

In 1976, after living on Turney Road for almost seventy years, Alexandra Flueck sold the house to Laureno and Pilar Viera.[43] The Vieras made this their home for twenty-two years, until 1998, when they sold it to Christopher McClatchey and Jeanne M. Stein-McClatchey.[44]

The site of the state hospital was redeveloped, and in the late 1990s, new homes were built there.

The McClatcheys sold the house to Willie F. Hodges in 2000.[45]

How Old, then, Is the House Itself?

The evidence tends toward a date after 1854 and before 1861. A house would not have been built in this style after the Civil War, and there was virtually no construction during the war. From the outside, it is difficult to discover much—the foundation stone is so abraded that we can't tell much about the age of the house from whatever tooling might have been present, and the wood siding was replaced at some point, losing some trim detail. The framing for the house appears to have been cut on a sawmill.

The front door, which has been boarded up, may reveal more of the story. Above the doorframe is a transom—a window, probably three or four panes.

While it is reasonably likely that this house was built in the 1850s, there's another possibility. When the property changed hands in the 1830s, the price suggested a major improvement to the property. Yet when Garfield sold the small lot to Miller in 1854, the price was less than what you'd expect for a lot with a solid dwelling.

There remains the possibility that the condition of the dwelling on the property had deteriorated significantly, declining in value. Miller might have fixed it up, or James H. Brown, an enterprising carpenter, might have renovated and expanded an existing structure.

This house is at least 150 years old. It has survived through the transition of this neighborhood from rural to urban. It has survived the rise and fall of industry. Yet now the current owner wants to demolish it (he has pulled a demolition permit for the property). As the house is not in a landmark district, he could proceed forward at any time.

Yes, this house does need some work. But it's not an insurmountable project. The interior, from what I could see, isn't especially scary. The historic details that remain are relatively easy to work with. The house has great proportions. It appears to retain most of the original double-hung windows.

This is the sort of house that neighborhoods are rebuilt around.

THE LAST PIONEER HOUSE

Leonard Case (1786–1864), a businessman and prominent early Clevelander, moved to the city in 1816 and built this house shortly after, at the corner of Rockwell Avenue and East Third Street. The home was documented in the 1930s by the Historic American Building Survey (HABS).

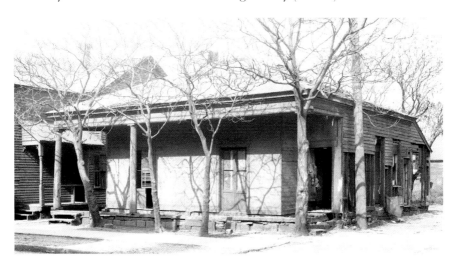

The Leonard Case house (circa 1820), Rockwell Avenue and East Third Street. Moved to 1295 East Twentieth Street, Cleveland, Ohio. Demolished. Photograph by Carl Waite for the Historic American Buildings Survey, November 2, 1936. *Courtesy of the Library of Congress.*

According to the HABS documentation:

> *The Case Homestead at Rockwell Avenue and East 3rd Street was sold at public auction to Attorney Charles E. Chadman for $340. It was moved from this site to a new location at 1295 East 20th Street.*
>
> *At the time the Case home was built the total population in Cleveland was between 1000 and 1500. This home, as one can readily understand from the size of the population, was built by one of the very early settlers and consequently is of considerable historic value. East 20th Street at the time of the removal of the house was considered "quite a ways out," and a select residential district; today, however, this territory is considered a "slum area."*
>
> *The house has served various purposes since its removal, one of the last uses was that of a restaurant. The members of the Historical Building Survey Squad who measured the building, did so in the nick of time, in that but a few days after completing the survey, the building began to disappear, as will be noted from the photographs. This destruction was in all probability the work of vandals or possibly people who were in dire circumstances and in need of fuel.*

In addition to exterior renderings, the documentation also includes floor plans, moldings and bits of trim. The house was moved to East Twentieth Street before 1881. It is shown at that location in the 1881 Hopkins atlas.

The site is now a parking lot.

Save This Greek Revival House!

Greek Revival is a style of architecture that was most popular in the United States from about 1800 to 1855. In vernacular form, the most defining element is a roof with a pitch similar to classic Greek temples, with the gable facing the street. I've always liked the style—particularly the way that it was realized in rural and small-town Ohio, both elegant and simple.

Recently, I started thinking about the possibility of the existence of Greek Revival houses in the city of Cleveland. I knew that they existed in the suburbs—I've lusted over an 1853 farmhouse at 23550 Fairmount Boulevard in Shaker Heights—but older areas of Cleveland have more frequently been redeveloped, replacing the oldest structures. But some must still be standing, I guessed. I started a quest to find as many Greek Revival houses in the city of Cleveland as I could.

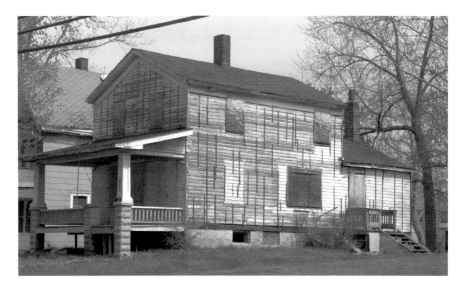

W. Lewis residence (circa 1850), 1209 East Seventy-first Street, Cleveland, Ohio. *Photograph by the author, April 14, 2010.*

My initial focus has been on the east side, where I live and work. I began by just driving up and down the streets, a photocopy of a local street atlas in hand, crossing off streets as I checked them. The first one I found, at 3370 East 130th Street, just north of Kinsman, encouraged me to look further.

In my quest so far, one particular house is the best one I've found that isn't currently being used as a residence. It is located at 1209 East Seventy-first Street, just north of Superior. The house needs work, but it's not too far gone. The lines are really clean, and the proportions are just right; I can also imagine how great it would look without the front porch (which was a later addition). Aluminum siding has been removed, which allows us to see the original locations of the windows on the first floor. It is possible that the windows on the second floor are original—they appear to be in the original locations.

I had originally assumed that the flat-roofed addition was built considerably later and was a probable candidate for demolition if the home was restored. I have looked at it since, though, and saw that the foundation for the addition was also made out of sandstone and had similar tool marks to the foundation on the main part of the house. I find it hard to believe that a structure with a flat roof could have lasted so long, but perhaps the roofline has been changed.

Imagine how this house and the adjacent property might look after a couple of years of work. You've removed the porch, replaced the rotten boards and painted the house white. A picket fence encloses your yard and

the surrounding lots, which you have purchased from the city. On one of those lots sits a garage, painted red, looking much like the sort of barn you'd find near a farmhouse like this in the mid-1800s.

BUILT BEFORE THE CIVIL WAR

I was browsing local real estate listings, searching for structures built before 1901, when I came across the house at 11713 Kelton Avenue in Cleveland. Something in the photo seemed not quite right—later I concluded that it was the sizing of the three windows on the second floor of the house. I double-checked the Hopkins 1858 *Map of Cuyahoga County*—this house was not indicated, nor was it close to any of the roads. I assumed that this house must be more recent and that this was simply a Colonial Revival house that happened to photograph like a Greek Revival. Still, I went out to look at it on my lunch break.

Upon seeing it, I had little doubt that this is a Greek Revival house, built before the Civil War. The foundation is from the early twentieth century, so I believe that it was moved.

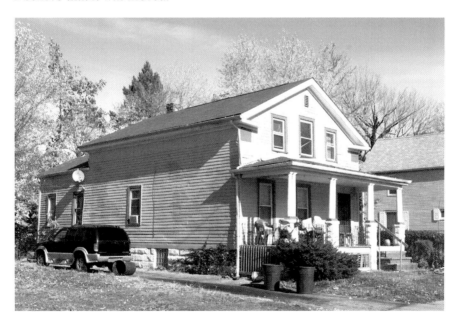

House, probably built on Euclid Avenue (circa 1850), moved to 11713 Kelton Avenue, Cleveland, Ohio, before 1881. *Photograph by the author, November 6, 2009.*

The level of detail in the trim suggested to me that this house might have been originally built on a busier street, probably Euclid Avenue. Even the front door has a nice bit of trim, though the door itself is later, perhaps the 1880s or 1890s. I'm still puzzled by the windows as a whole—were they originally in different places? It just feels strange to see three windows across the second floor of a Greek Revival house, without any symmetry with the windows on the first floor.

Picturesque America is a massive two-volume set, first published in 1872 (D. Appleton and Company, New York). Its primary appeal was its extraordinary illustrations of notable natural features across the United States. In a way, it was the first popular book of the genre we now call "coffee table books." In addition to natural wonders, it provides glimpses of major cities across the country, Cleveland among them.

Cleveland's chapter opens with *Mouth of Cuyahoga River, Cleveland*. If compared to Otto Bacher's prints and drawings of Cleveland of the same area at about the same time (see "A Portrait of the City by a Young Artist—Cleveland in the 1870s"), there is a quality of composition that is shared, but Bacher's vision is veiled, perhaps because he is more concerned with qualities of light.

This is followed by *Cleveland, from Scranton's Hill*. The location today is close to West Seventeenth Street, just north of Lorain Avenue, immediately before it crosses over the Cuyahoga River and becomes Carnegie. From this promontory, we can see a good part of the

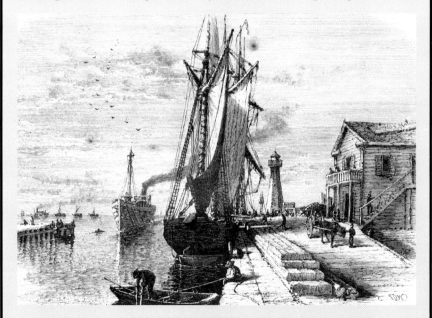

Mouth of Cuyahoga River, Cleveland. Published in *Picturesque America*.

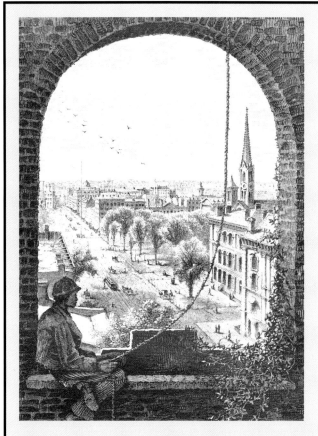

Superior Street, Cleveland, from Presbyterian Church. In the distance, Public Square is visible. Published in *Picturesque America*.

residential area of the city, as well as the growing industrial flats by the river.

A church provides a view of downtown Cleveland, looking west, in *Superior Street, Cleveland, from Presbyterian Church*. Second Presbyterian Church was located on the south side of Superior, near where the Old Arcade is today. In the midground, there are the trees of Public Square and the Old Stone Church—the one structure that remains from this historic view. In the background, on the right side of the street, is a building with a dome. This is the Weddell House, one of the city's best-known hotels.

On the following page, we are provided with a view of Euclid Avenue, looking east, from about East Thirteenth Street. The church in the foreground is the Euclid Avenue Presbyterian Church. It was located at what is now East Fourteenth Street. In the distance, we can see the tower of the Euclid Avenue Baptist Church, at the corner of East Eighteenth Street.

City of Cleveland, from Reservoir Walk. The site, in Ohio City, is part of the block that includes Fairview Park. Published in *Picturesque America*.

The Ohio City neighborhood is illustrated in the engraving *City of Cleveland, From Reservoir Walk*. The reservoir was located on the block bounded by Franklin Boulevard on the north, West Thirty-second Street on the east, Woodbine Avenue on the south and West Thirty-eighth Street on the east—the block that now includes Fairview Park.

The high earthen banks of the reservoir provided an excellent view of the city. About a third of the way in from the right, the Methodist church is visible; just behind it is the steeple of the Baptist church; and off center in the distance is the First Congregational Church. In the distance is Lake Erie.

The two remaining views of the Cleveland area are both of the Rocky River. One provides a view from close to the river itself. The other shows the lake from an overlooking bluff.

As was typical of *Picturesque America*, these views provide an idealized view. Looking at them and then at Cleveland as seen by Otto Bacher is an interesting exercise. Bacher's drawings and prints provide a personally distinctive, and more intimate, perspective.

Part II

BUSINESS

THE DUNHAM TAVERN

Have you ever noticed the old wooden building in Midtown on Euclid Avenue, standing next to a massive old industrial structure, and wondered what it was doing there? The building is the Dunham Tavern Museum. Located at 6709 Euclid Avenue, the tavern is the oldest building still standing on its original foundation in the city of Cleveland. The oldest part of the tavern, seen here to the right and rear, was built in 1824 to serve travelers at a time when Euclid Avenue was the major east–west road. The main part of the building was built in 1842.

The present entry is through a door on the side, which opens into the oldest part of the building. This space contains a large kitchen, with living quarters on the second floor.

A dining room is located between the tavern and the front hall. The parlor, on the opposite side of the front hallway, provided a space for guests to sit and relax. Historically, guests entered through the front hall, handsomely appointed with wood paneling lining the hallway and stairs.

The second floor has several bedrooms, all furnished with period antiques, including a dresser that was original to the building. The museum's library is also located on the second floor.

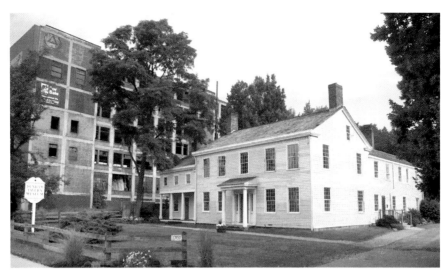

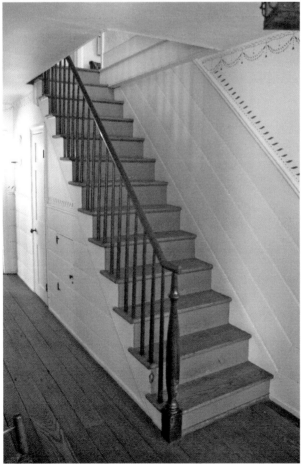

Above: The Dunham Tavern (1824), the oldest building in Cleveland still on its original foundation, 6709 Euclid Avenue, Cleveland, Ohio. *Photograph by the author, July 8, 2011.*

Left: The Dunham Tavern front stairway. *Photograph by the author, February 17, 2010.*

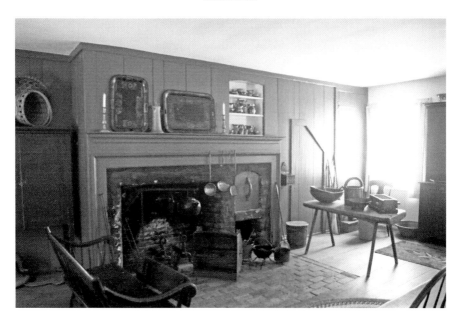

The Dunham Tavern kitchen. This is in the oldest part of the structure. *Photograph by the author, February 17, 2010.*

It's amazing that the Dunham Tavern has been able to survive, particularly in contrast to the derelict, seven-story, massive brick and concrete structure next door. I hope that the industrial structure remains, because it provides context to the tavern's presence in the heart of an ever-changing city.

LAST OF THEIR GENERATION: THE TWO OLDEST BUILDINGS IN DOWNTOWN CLEVELAND

For much of the life of the Mechanics Block (built about 1835, demolished 1971; see the following section), it wasn't seen as that significant—there were plenty of larger, more important buildings in Cleveland at the time of its construction. But as the other buildings of its time were lost, it gained importance as a survivor. At the time of the demolition, the Mechanics Block was the oldest building in downtown Cleveland.

The two oldest buildings presently in downtown Cleveland present much the same problem. While they were good examples of the style for the time they were built, they weren't considered fancy or otherwise architecturally special. They had escaped academic notice as late as 1964, when Edmund H. Chapman's

The Hilliard Block (circa 1850), 1415 West Ninth Street, Cleveland, Ohio. *Photograph by the author, July 9, 2011.*

classic analysis of the city's growth, *Cleveland: Village to Metropolis*, was published. Only now, as the last of their generation, have they become important.

The Hilliard Block, at 1415 West Ninth Street in Cleveland, was constructed circa 1850. It was built for Richard Hilliard's grocery business, Hilliard and Hays. Hilliard, a Cleveland resident since 1824, was involved in both business and politics. He was elected president of the village council twice in the early 1830s, and in 1836, when Cleveland became a city, he was elected alderman.

The condition of this late Federal block has improved considerably since it first received attention in *Landmark Architecture of Cleveland* by Mary-Peale Schofield in 1976. Since then, the building has been restored. The chimneys, built right into the sides of the structure and which were missing in 1976, have been reconstructed. The peeling paint (and lovely patina) of the sign reading "Drug Sundries Co." is now gone, replaced with paint in a color similar to that of the bricks.

The Central Exchange, now Frank Morrison & Son, is similar in style. This historic structure, at 1330 Old River Road, was built at about the same time as the Hilliard Block, about 1850. Schofield's guide is the first publication to notice the historical importance of this structure as well.

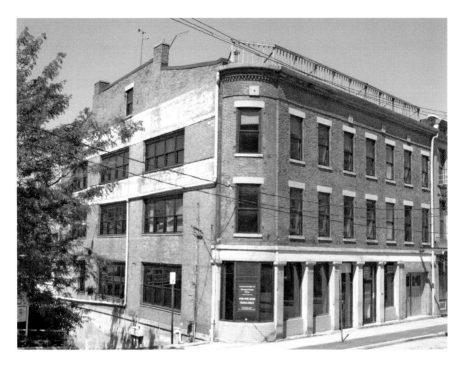

The Central Exchange (circa 1850), 1330 Old River Road, Cleveland, Ohio. *Photograph by the author, July 9, 2011.*

The Central Exchange is wedge shaped. Schofield noted that part of the riverside dock remained. The windows on the side of the structure have been widened—they would have originally been of the same proportions as those on the front of the building, like the Hilliard Block. The unusual curved corner of the front of the building is original.

THE MECHANICS BLOCK

Think about the Cleveland landscape in 1833: in your mind, try to animate the Cleveland of Thomas Whelpley's print portfolio (see "Thomas Whelpley's Cleveland, 1833"). It still resembled a New England town. Cows grazed at East Ninth Street even as it was becoming prosperous.

This landscape is so far removed from what we know today that it's hard to imagine it as being the same city we are in today. Yet at about this time (some sources say 1832, more say 1838), a building was constructed that remained part of downtown life until 1971.

The Mechanics Block (1838), the oldest building in downtown Cleveland at the time, two months before demolition, 2095 Ontario Street, Cleveland, Ohio. *Photograph by Sigmund R. Cobus. November 1970.*

The Mechanics Block was built at the southeast corner of Prospect Avenue and Ontario Street. At the time of its construction, it must have surely been grand, particularly if we are to compare the buildings of a few years earlier.

The Mechanics Block housed several schools and other organizations until 1903, when it became home to the Richman Brothers department store. Richman Brothers eventually expanded to fill part of the neighboring Stanley Block (see the following section).

When it was demolished, it was not due to structural issues or problems with condition but rather because the owner felt that the land was more valuable without the building. The public outcry led to the founding of what would become the Cleveland Restoration Society, Cleveland's historic preservation advocacy organization.

Historical buildings in the fabric of the urban environment are part of what makes the city interesting. In the historic areas in our city, we shouldn't discard important structures because of the often arbitrary decisions of one individual, corporation or institution.

It's about the interests of the population as a whole. This is why we have building and zoning codes—and why they need to be enforced.

CONDEMNED: THE STANLEY BLOCK

This building, at 2121 Ontario Street, has been condemned. It's on the east side of the street, between Prospect and High. Known as the Stanley Block, it is one of a few stone-faced commercial buildings of this vintage still standing in Cleveland. The Stanley Block has had an interesting history, due partially to the ballroom on its top floor, where many meetings and events were held.

The Stanley Block (circa 1870), 2121 Ontario Street, Cleveland, Ohio. *Photograph by Tim Barrett, 2010.*

This block, located at 174, 176 and 178 Ontario by the pre-1905 street numbering system (2115, 2119 and 2121 Ontario today) was probably built in 1874,[46] and definitely in the 1870s, for G.A. Stanley.

The first floors housed a variety of businesses. An 1877 ad read: "Mr. George Angel, the well known dealer in Boots and Shoes for twenty years, at No. 39 Superior street, has moved up town to No. 174 Ontario street, where he has opened a large and varied stock of Boots and Shoes. Good goods and low prices will be the rule at the new store."[47] Mr. Angel's business did not last long at this location, however; a year later, an ad was published by his trustees, looking for proposals for the entire stock of the shop.[48]

Other early businesses using the retail space include the Star Book and Shoe Company, which also had locations at 112 Ontario and 98 Public Square;[49] the United States Jewelry Company;[50] a music teacher, F.M. Stebbins;[51] and a dance teacher, "Professor Cooper," who had four assistant teachers from New York and who "[w]arrants all to be good dancers in six lessons."[52]

The fourth-floor ballroom, known originally as Gesangverein Hall, had a bustle of activity. A wide variety of fraternal and social groups held their meetings there: "Rothschild lodge, No. 17, K.S.B., will give a grand ball in Gesangverein Hall, No. 174 Ontario street to-morrow evening. The proceeds are to be devoted to benevolent objects";[53] a "Cleveland Gesangverein concert";[54] the Young Men's Hebrew Association ball;[55] the Austin Post 403, Grand Army of the Republic (GAR) grand military ball and concert;[56] and the ball of ODIF Sahbele Lodge 6, with music by Professor Straube's orchestra.[57]

In 1888, the Ancient Order of Hibernians held its county meeting at the hall.[58] The club obtained a five-year lease on the hall, which was to be overhauled and would become known as Hiberian Hall.[59] In the years that followed, the hall began to be used for meetings by labor organizations struggling for social change.

A wide variety of unions used the hall for meetings. The barbers union met several times, both for general meetings[60] and with regard to the arrests of those who worked on Sundays.[61] The Central Labor Union began meeting there in 1891.[62] And Samuel Gompers, founder of the American Federation of Labor, gave a free speech.[63]

Fraternal groups continued to use it regularly as a meeting venue. These included the Ancient Order of Hibernians[64] and the Justice Command, Union Veterans' Union.[65]

A meeting to unionize foundry workers was held in the hall on Sunday, March 15, 1891,[66] as was a more general one, to "organize all industries."[67]

These meetings became more political, as indicated by a joint meeting of the Nationalists, the Knights of Labor and the "adherents of the citizen's movement," with regard to the alleged Republican forgery of votes.[68]

Metal polishers met here,[69] as did members of the Iron Molders Union. Joseph Valentine, first vice-president of the Iron Molders of North America, spoke. "Valentine is a very pleasing speaker and his utterances were received with applause."[70]

In the 1890s, there was an increase in ads for businesses using the first-floor retail space. One, for the Miller Tea Company,[71] lists offerings, including sugar, tea, raisins and free boxes of Christmas candy.

Hibernian Hall remained an important meeting location for labor unions, including the Master Horse Shoers' Protective Association[72] and the Bricklayers Union No. 5.[73] The Bricklayers Union meeting was "largely attended." It was noted that they were displeased with the way nonunion men were being brought into the city.[74] General Master Workman (from 1893 to 1901) J.R. Sovereign of the Knights of Labor also spoke at the hall.[75]

In 1895, P.J. McGuire, national secretary and treasurer of the Carpenters' Union and first vice-president of American Federation of Labor (AFL), spoke to an open meeting of the Carpenters' Union. Four hundred people were said to be present. That year, it became known as Blahd and Heller's Hall.[76] After this, we don't see many notices regarding the meetings of labor unions at the hall.

Other businesses and professionals occupying the space include Dr. Le Roy;[77] the U.S. Renting Agency, which offered "furnished or unfurnished rooms in any part of the city";[78] and People's Shoe Store.[79]

Richman Brothers clothing store began using the building to the north, the Mechanics Block, and obtained space on the upper floors of the Stanley Block.[80] In 1924, the entire first floor was occupied by a Woolworth's five-and-ten store.

Clay Herrick Jr. noted the significance of this building in *Cleveland Landmarks*. He stated that the ballroom was where Frances Payne Bolton (the first Congresswoman from Ohio, serving 1939–68) made her debut. In 1981, when the Cleveland Landmarks Commission asked the Cleveland Chapter of the American Institute of Architects to select several buildings to identify for restoration, this was one of those chosen.

The Stanley Block has been owned since at least 1975 by George M. Maloof or, more recently, by the Macron Investment Company, for whom Maloof is the contact agent. They do not appear to have been good stewards of this piece of our history. One might guess, based on the lack of care given to the structure, that the condemnation will not be fought.

The taxable value of the property as vacant land is far smaller than as a commercial structure. If demolished, it will likely sit as surface parking until it can be redeveloped.

This is a beautiful old building, with a great history, both in society and organized labor. There are very few stone-faced commercial buildings of this vintage left in Cleveland. It appears to be a solid shell that could be rehabilitated without excessive costs.

Since this was written, the Stanley Block has been made a Cleveland Landmark, affording it some measure of protection.

THE HOUSE OF A SHIPBUILDER

Number 5611 Lexington Avenue is a designated Cleveland Landmark, built in 1854 by Luther Moses, a prominent shipbuilder. The west side of the house was originally the front, facing East Fifty-fifth Street.

The residence of Luther Moses, a prominent shipbuilder (1854), 5611 Lexington Avenue, Cleveland, Ohio. *Photograph by the author, June 9, 2011.*

The front door, now bricked in, was centered between two pairs of windows. Behind the brick, much of the front doorway remains. It is simple, with a transom and sidelights, much like the Brainard house (see "Now We See It, Now We…"). Front steps, and possibly a porch, from the original construction are missing now. A Gothic-arched window, now partially bricked in, was centered over the front door. It was still present in 1975.

When I first saw the house, I forgot that it was built before Lexington Avenue was cut through. What was originally the side of the house now faces the street. I had felt uneasy about the date given the house by the Landmarks Commission—the house, from the side, just didn't feel like an 1850s house. And from that angle, it isn't—it has characteristics of the time the house was modified to face Lexington.

There were originally three windows, evenly spaced, on the first floor of what is now the front of the house. One of them has since become a door. On the second floor, the windows seem to be in their original locations. The current main entrance was added later, when a porch was built on the house. The lintel over the smaller window seems a bit (visually) heavy, but that might just be due to an excessive amount of mortar above and around it. What is now the back of the house was originally a side. It is very similar to the side that is now the front. I don't see evidence of a third window on the first floor, so it isn't an exact mirror. I suspect that the changes to the second-floor windows were made at the same time that an addition was built, due to similarity in the style of the arches. Lintels were replaced with arches, and the double window to the west was expanded from a single.

Inside, most of the original woodwork is still present. The doors are all framed by detailed trim, as are the windows, the trim for which stretches all the way to the floor. There are two fireplaces, one of which retains the original detail as well. Over all, this house displays the highest quality interior that I know of for a pre–Civil War house in Cleveland, east of the Cuyahoga River.

The only spot of immediate concern for the structural integrity of this building is an area on what used to be the front of the house. It is directly below a valley on the roof, so a large quantity of water gathers here when it rains. New gutters would keep this problem from getting worse.

The present owner appears to have some interest in the preservation of this property. The roof was recently replaced, which offers some measure of protection, but for some reason the shingles have refused to remain attached.

GARFIELD SAVINGS BANK

The Garfield Savings Bank building at East Seventy-ninth Street and St. Clair Avenue in Cleveland was designed by Walker and Weeks, the noted Cleveland architects responsible for the Cleveland Public Library main library, the Federal Reserve Bank of Cleveland, Cleveland Municipal Stadium, Public Auditorium and Severance Hall (see "The Bare Bones of Severance Hall").

Eric Johannesen, in his authoritative work on the architectural firm, *A Cleveland Legacy: The Architecture of Walker and Weeks*, noted of the bank:

> *Of the many smaller banks, one of the more striking buildings was designed for the expanding Garfield Savings Bank in Cleveland, for which Walker and Weeks planned two branches in 1915. The building on St. Clair Avenue at East 79th Street stands at the triangular intersection of three streets and forms an irregular quadrilateral with the entrance at the narrow end, framed by two Tuscan columns. Like many bank buildings of the period, it incorporated space on two stories for rental as retail stores. But unlike most, it is built of brick rather than stone.*

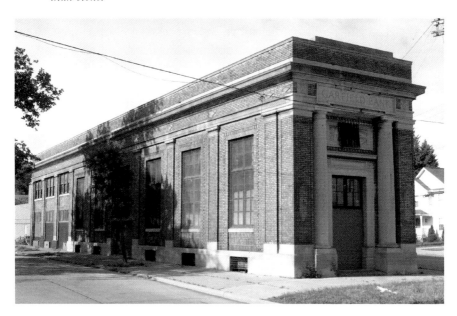

Garfield Savings Bank (1915), East Seventy-ninth Street and St. Clair Avenue, Cleveland, Ohio. Walker and Weeks, architects. *Photograph by the author, June 30, 2011.*

The other branch that Walker and Weeks designed for Garfield Savings Bank was located on East 105th Street.

Garfield Savings Bank was founded in Cleveland on May 16, 1892. The *Proceedings of the Annual Convention of the American Bankers Association* for 1917 lists a main bank and four branches. The branches were located at St. Clair and East 105th Street, St. Clair and East 72nd Street, Superior and East 105th Street and 11803 Euclid Avenue. None of these buildings remain.

The *Fourteenth Annual Report of the Department of Banks, Fiscal Year Ending June 30, 1921* provides a detailed picture of the bank, which at the time had assets of $17 million. The bank merged with Cleveland Trust in 1922. At the time, the bank had $15 million in deposits and sixty-six thousand depositors.[81] The building was sold to Haddam Building Company in June of that year.[82]

The Haddam Building Company was founded sometime before 1906. It occupied this building until 1938, when it was sold to Ellie Barsan. In 1944, the property was transferred to Virginia Barsan, who owned it until 1977. It has changed hands frequently since then.

The larger windows open into the lobby of the bank. The smaller windows, split into two stories, would have been for commercial rentals—shops or offices.

Out of Place?

When I first saw the apartment building at 8115 Wade Park Avenue in Cleveland, I thought that the beautiful façade looked a bit out of place compared to the ordinary structure of the apartment block behind.

I discovered that the building had been built in 1901 for Genesee Savings and Bank Company. The architects were Steffens, Searles and Hirsh. The Ohio Savings Bank building, at 1868 West Twenty-fifth Street in Ohio City, is one of the architectural firm's notable commissions.

The bank occupied half of the first floor. Another commercial enterprise rented the other half. The second and third floors were apartments. The north side of this block of Wade Park was built this way—apartment blocks, most with retail on the first level.

The design of the block explains the construction of this structure—the sides wouldn't have been seen because they would have been almost touching the adjacent buildings.

Immediately to the west of this building was a bowling alley. At the east end of the block was a drugstore.

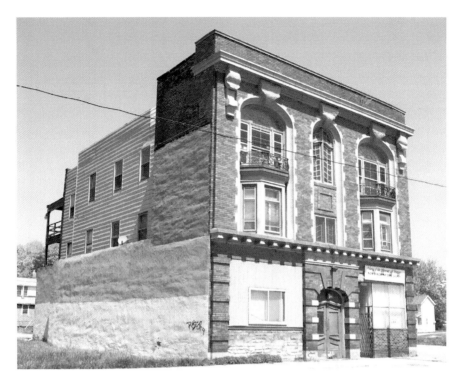

Genesee Savings & Bank Company (1901), 8115 Wade Park Avenue, Cleveland, Ohio. Steffens, Searles and Hirsh, architects. *Photograph by the author, April 21, 2010.*

For an apartment building, the finish quality is impressive. It was clearly designed to appeal to affluent renters. There is an extraordinary level of detail in the windows and in the railings on the balconies.

Otto Henry Bacher was born in 1856 in a house on River Street (now Old River Road) near St. Clair Avenue. He was one of the first artists to begin to study art in Cleveland and then to later achieve national prominence. These images are the work of a young artist—they are from 1877 and 1878, when he was in his early twenties, just before he left for Europe to further his studies.

The works reproduced here are from the collections of the Cleveland Museum of Art. Except where noted, these are etchings, the medium in which Bacher became best known. (An etching is a type of print where an artist draws on a wax-covered metal plate and then uses an acid bath to etch the metal where the wax has been removed.)

Through these views, we can see how Bacher perceived the city around him. We have plenty of historic photographs illustrating the city, but these images are different. Bacher selected scenes for the aesthetic merit of composition, as well as for his personal response. As a result, we have images that portray what might have been thought too insignificant or too ordinary to photograph.

Are these as factual as photographs of exactly how things were on a day in 1878? No, no more than a journal of a conversation can be as factual as

Otto H. Bacher (American, 1856–1909). *Spring Street, Cleveland* (detail), 1878. *The Cleveland Museum of Art. Gift of Mrs. Mary H. Bacher, New York 1915.420.*

Otto H. Bacher (American, 1856–1909). *West Pier* (detail), 1878. Etching. *The Cleveland Museum of Art. Gift of Mrs. Arthur F. Weaver in memory of Charles H. Weaver 1921.188.*

a recording. But like a journal, they are better at the valuable nuances of individual perception. Through Bacher, we can feel something of what it felt like to be in Cleveland in the 1870s. Many of Bacher's Cleveland works focus on the area where he was born and grew up, close to the Cuyahoga River.

The etching *Spring Street, Cleveland* (now West Tenth Street between Front Street and St. Clair Avenue) depicts a place probably less than a block from where he lived. Small houses and sheds, which were probably residences, suggest poverty in the area. Clothes hang from lines on the slope to the right. Children play in the street, and pedestrians walk on the left. At night, the street was illuminated by lamps.

West Pier, or Government Pier, was located on the east side of the mouth of the Cuyahoga River. In the foreground and midground, we can see several buildings associated with the activities of a port. In the background, the rigging and masts of a ship are visible, as is a lighthouse.

Ship and Elevator probably shows the Union Elevator (the only one indicated on period maps) on Merwin Avenue near British Street. A

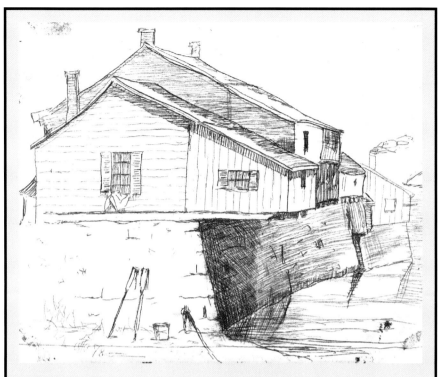

Otto H. Bacher (American, 1856–1909). *Cottages, Cleveland* (detail), 1878. Etching. *The Cleveland Museum of Art. Gift of Mrs. Mary H. Bacher, New York 1915.422.*

ship is docked while it waits to load or unload. In the midground, a man sits with his dog. The commercial structures were almost certainly brick, judging by the stone lintels over the window frames.

The etching *Old Passenger Depot* depicts a location due north of the area depicted in *Spring Street, Cleveland* on the edge of Lake Erie. By this time, it had been replaced by the Union Passenger Depot, built to the east of this site. The old depot had been abandoned and was deteriorating, with missing panes of glass in the windows and missing planks in the boardwalk.

In *Cottages, Cleveland*, we catch a glimpse of several tiny houses, probably along the Cuyahoga. In expanding the structures, additions were built that are hanging over the river. The historical record is full of photographs and prints of the houses of the upper classes, lining Cleveland's avenues and boulevards, and there is a reasonable sampling of the houses of the middle class. There is very little documentation of residences like these.

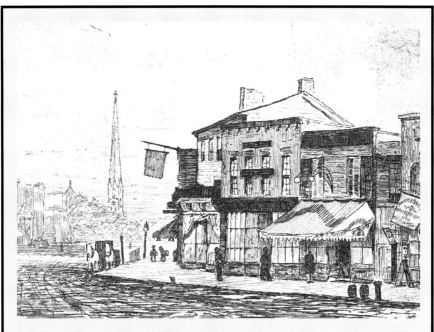

Otto H. Bacher (American, 1856–1909). *Cleveland, Woodland Avenue and Eagle Street* (detail), 1878. Etching. *The Cleveland Museum of Art. Gift of Mrs. Mary H. Bacher, New York 1915.427.*

The etching *Street Scene, Cleveland* has the same landscape as the northern corner of Old River Road and West Tenth Street, but it is impossible to be sure of the location. The layout of the streets is consistent, and it is Otto Bacher's neighborhood. The street is unpaved, the sidewalk is broken and the buildings tilt.

The etching *Downtown, Cleveland* appears to show Superior Avenue looking west from Public Square, based on the layout of streets and the slope of the road in the distance. In the road is a trolley or streetcar, as well as the tracks that it travels. The bustle of commerce is obvious, with carriages and wagons lining the roadway.

The Square illustrates the southwest corner of Public Square. Pedestrians walk along the sidewalk, and a horse and carriage are on the roadway. A streetlight leans at an angle.

Cleveland, Woodland Avenue and Eagle Street reveals, in the distance, an architectural element present today: the tower of Old Stone Church. Though dwarfed by skyscrapers at present, it's important to realize the way the church towers must have been visible over much of the area, commanding the skyline. This view, looking about north-

northwest, shows an area that is now Progressive Field. Hanging over the entrance of one business are the three balls that are associated with pawn shops.

The etching *Tower of the Chimes, Old Trinity, Cleveland* depicts the tower of the Episcopal church on the south side of Superior Avenue, just east of where the Old Arcade now stands, which is just west of East Sixth Street. The most interesting part, to my eyes, is the unevenness of the land, which has now been completely flattened. (You can see the unevenness of the original landscape today in the Old Erie Street Cemetery on East Ninth Street.)

These are a few of the many images that Otto Bacher created as a young man, his eye and hand responding to his hometown. His personal perspective helps to make the atmosphere real, to imagine what we'd see on the city streets.

INDUSTRY

HIDING IN PLAIN SIGHT: THE LUSTER TANNERY

When I first saw this stone building at 16360 Euclid Avenue on the border of East Cleveland and Cleveland, I knew that it was from an early time, based on the way the stone was worked by hand. The tooling of the stone is similar to that seen at the Rodolphus Edwards house and the John Honam house (the Old Stone House in Lakewood; see "Quarried on Site: The Rodolphus Edwards House"). I asked Roy Larick, who has done considerable research into the Euclid Creek and Bluestone Heights area, about the building. I knew that he'd know about it and be interested. He did know about it but said that he hadn't been able to learn much—other than seeing it indicated on a few maps, the only information he'd been able to find was this paragraph from *A History of East Cleveland* by Ellen Loughry Price:

> *Sam Ruple and his family settled at Nine Mile Creek in 1805. The story is that the family had come from a Ten Mile Creek and considered this place a little less desirable than the old one—hence the name. He established a tannery there, later owned by the Luster family. The water from the creek was diverted into the basement vats of the stone house, and then out again into the creek. Mrs. Ruple fed a frightened run away squaw, and later fed and tried to delay a group of Indians in pursuit of her. But it was to no avail and they later returned with the captive.*

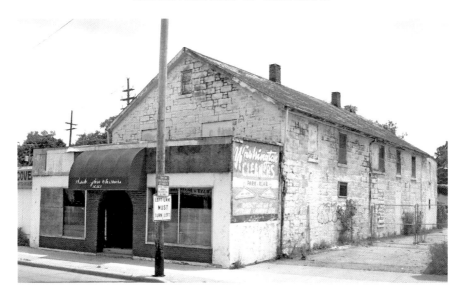

The Luster Tannery (circa 1850). The structure, on Nine Mile Creek, was built for tanning leather. It is the earliest surviving industrial structure in the city, 16360 Euclid Avenue, Cleveland, Ohio. *Photograph by the author, June 30, 2011.*

I looked extensively for information about Samuel Ruple, with little luck. Eventually, I concluded that, as the previous passage indicates, he did settle in 1805 and owned a considerable amount of land around Nine Mile Creek. Evidently, he was a prosperous farmer. However, no evidence other than this passage suggested that he was involved in the business of tanning leather. Plenty of evidence, however, documents the Luster family as tanners, as well as operators of a tannery at this location.

Samuel and Susan Luster were probably both born in Canada, in 1800 or 1801. The 1900 census (which had questions about ancestry), however, notes that they were born in France and Ireland, respectively. Their first child, Samuel S. Luster (hereafter Samuel Jr.), was born in 1823 in St. Thomas, Ontario. They had moved to Euclid Township before the birth of Catharine Luster in 1830.

According to an obituary for Samuel Jr., "As soon as the boy grew up he became a tanner and for many, many years, had a tannery on Nine Mile creek in Collamer."[83] This suggests that he had become a tanner by the time he was twenty or so, or about 1843. Samuel Jr. purchased the land that the tannery is on, about seventeen acres, from Levi and Sophia Billings in 1848 for $1,000.[84] The exact date of the construction of the tannery is unclear, but it was probably after 1848. The remainder of the seventeen acres was used for farming.[85]

The 1850 census lists Samuel Jr. as a "Tanner and Currier." It also describes Samuel Luster as a farmer. It notes several other children: George (eighteen), Sanbarah (fifteen), Elizabeth (twelve) and Harriet (seven).

The 1858 Hopkins *Map of Cuyahoga County, Ohio* shows the property of S. Luster on Nine Mile Creek—about fourteen acres. An inset detail, Collamer Village, reveals a "Tannery and Shoe Shop by S. Lute." Given the similarity of the name to S. Luster, and later sources, we can safely assume that this was an error for "S. Luster." The map shows the upstream extent of Luster's holdings, including quite a bit of Nine Mile Creek.

The construction of the tannery tells us quite a bit about the state of Samuel Jr.'s business. It would have been expensive and time-consuming to build from stone instead of wood. In most of the places in northern Ohio where we see buildings built from stone, it is because it was readily available near the building site. The use of stone suggests that the tannery business was already doing well, that Luster wanted to create the impression of importance or that it was necessary to have a structure that would withstand spring floods.

The 1860 census lists Samuel Jr.'s occupation as "Master Tanner," an owner of real estate worth $4,000 and personal property worth $2,000.

Samuel Jr. and Helen Ellsworth Luster married in 1863. They remained in East Cleveland, where Samuel Jr. built a house on the north side of Euclid Avenue, across the street from the First Presbyterian Church.[86] This lot was purchased in 1866 from Henry Coit,[87] and construction likely commenced shortly afterward. Helen gave birth to ten children, seven of whom were living as of 1900. Samuel Luster died in 1867, and Susan Luster likely died between 1860 and 1870.

In 1870, the census indicates Samuel Jr.'s occupation as a tanner. The same year, for $604.50, Samuel Jr. purchased eighteen acres of land from Agnes McDonald and Flora and John Parker.[88] He used the land, on Noble Road, as a vineyard. This site is now part of Nela Park. Neighboring farmers also grew grapes.

The 1874 *Atlas of Cuyahoga County, Ohio* shows the Luster house, tannery and farm. A building owned by S. Luster is shown on the plate covering the southern half of Euclid in the 1892 *Atlas of Cuyahoga County and Cleveland, Ohio*, though it is not indicated as a tannery.

The 1900 census lists their address as 4277 Euclid Avenue in East Cleveland. This is presumably the house facing the First Presbyterian Church. Samuel Jr. and Helen had retired. Six of their children were still living with them. Burt Luster, born November 1864, was a farmer. Ernest

Luster, born March 1869, was a carpenter. The following were all teachers: Ellen Luster, born 1871; May Bell Luster, born 1875; and Blanch E. Luster, born 1877. Samuel Jr.'s obituary noted that "[i]n later years, he retired to his farm and lived quietly."[89]

The 1903 *Maps of Cuyahoga County Outside Cleveland* show Ellen Luster as owner of the farmhouse opposite the First Presbyterian Church. It also shows S. Luster as owner of the land on which the tannery sits.

Helen Ellsworth Luster died in 1905. Samuel Luster Jr. died from heart-related problems in 1907 in his residence in East Cleveland.[90] The funeral was held in his residence. His obituary described him as a "pioneer tanner" and noted that at the time, he was the second-oldest person in East Cleveland. He was survived by five children: Bertram E. Luster of Euclid and Ernest Luster, Mrs. C.W. Dille, Mrs. Norman Parks and Mrs. W.W. Herron, all of East Cleveland.

In the 1914 *Plat Book of Cuyahoga County*, the Luster farmhouse was noted as being owned by E.W. Luster.

To summarize: the building was built by the Luster family as a tannery between 1848 and 1858. It was built into the hillside, so that "[t]he water from the creek was diverted into the basement vats of the stone house, and then out again into the creek." The land surrounding the tannery was used as a farm, which, when combined, provided sufficient revenue to purchase additional land in 1870, which was used as a vineyard.

Taxes have not been paid on the Cleveland portion of the building since 1999 and on the East Cleveland portion since 2004. They amount to almost $40,000. This early industrial structure is unlike any other in the area. There aren't any other stone commercial or industrial buildings of this age in Cuyahoga County. From its time, the few stone buildings that are larger are churches. It spans the economic activity of the area from rural enterprise to an urban commercial center. We need to evaluate the interior of this building and reuse it to catalyze the rebirth of this community and of Nine Mile Creek.

THE FIFTY-THOUSAND-TON MESTA PRESS MATTERS

When I first heard about damage to the fifty-thousand-ton Mesta press at the Alcoa Works in Cleveland, it did not seem important, but I followed up by researching the Historic American Engineering Record's documentation of the press.

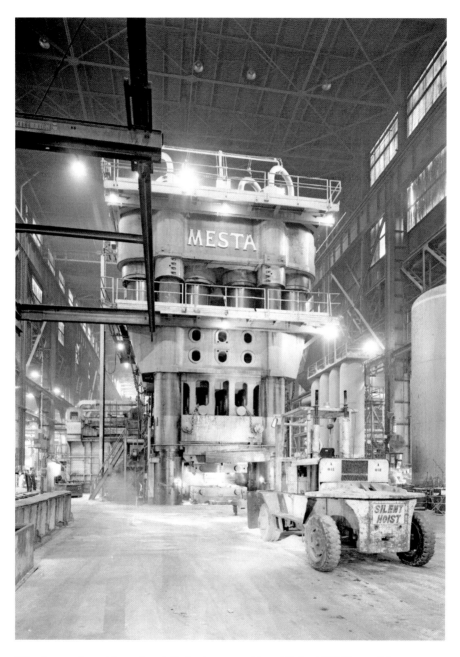

Fifty-thousand-ton Mesta closed die forging press, Alcoa Works, 1600 Harvard Avenue, Cleveland, Ohio (1955). Photograph by Jet Lowe for the Historic American Engineering Record, May 1985. *Courtesy of the Library of Congress.*

The fifty-thousand-ton Mesta press has been designated a Mechanical Engineering Landmark by the American Society of Mechanical Engineers (ASME), one of about 250 sites worldwide to receive this recognition. Its brochure for the dedication ceremony helps to explain the historical significance of the press in the history of the Cleveland and the aerospace industry:

The Mesta 50,000 ton hydraulic closed die forging press, this country's largest forging machine, is currently producing the largest light metal forgings in the world.

This massive forging tool actually had its genesis during the days of World War II. Allied intelligence teams inspecting German aircraft downed behind our lines discovered that they contained extremely large and complex major structural elements. Our appraisal of the situation, confirmed immediately after the end of the war, was that the Germans had produced these aircraft components with the aid of huge forging and extrusion presses possessing capabilities far in excess of those in our own industrial complex.

The implications were far-reaching. If forgings and extrusions large enough to comprise key aircraft structural elements could be produced in this country, not only would fabrication time be reduced greatly, but costs would be lowered. In addition, such a technique held the promise of forging materials with greater strength-weight ratios, an extremely desirable attribute from the standpoint of aircraft design. Just before the conclusion of the war, the United States embarked upon an urgent program to build a press able to match our estimates of the productive capability of the German equipment. The Mesta Machine Company of Pittsburgh was awarded a contract to construct an 18,000 ton forging press, and the Wyman Gordon Company of North Grafton, Massachusetts, was selected to operate it. Since the press was so enormous, a pattern to be followed when the press program went into full swing was established—a plant had to be built around the press to house both it and its supporting equipment. The war ended, however, before the project was fully completed.

When our technical/industrial teams visited Germany after the cessation of hostilities, they found that the Germans had indeed developed and learned successfully to operate presses ranging up to 30,000 metric tons. In all, three heavy die forging presses, two with a capacity of 15,000 metric tons and one with a 30,000-ton capacity, were discovered in more or less useable condition. Three extrusion presses in the 5,000 metric ton category were also located. As part of the postwar settlement, the United States acquired the 15,000 and 5,000 metric ton presses which were channeled

into the Air Force Heavy Press Program. The 30,000-ton press, however, was seized by the Russians. With the Soviets in possession of so large a press, our Heavy Press Program received added impetus.

As of now, reports are that the press will be rebuilt. Alcoa might not have any option—the press has produced some of the largest single structural elements for air and spacecraft and, these are parts that simply cannot be produced in any other facility.

The fifty-thousand-ton Mesta press is a vital element in the history of industrial Cleveland, as significant as the Hulett ore unloaders.

HULETT ORE UNLOADERS IN ACTION!

The Hulett ore unloaders (designed by Clevelander George Hulett) were massive machines that revolutionized the process of removing ore from freighters throughout the Great Lakes. The four here in Cleveland on

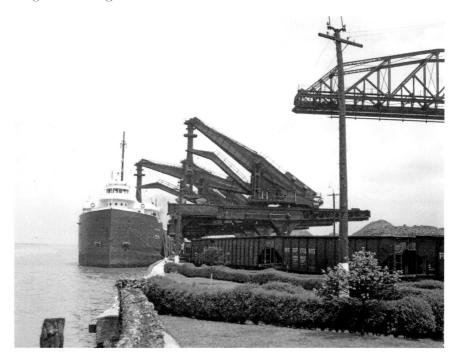

This page and next: Hulett unloaders, removing ore from a lake freighter, Pennsylvania Railroad docks, Cleveland (1912). Photographs by Jack Delano for the Office of War Information, May 1943. *Courtesy of the Library of Congress.*

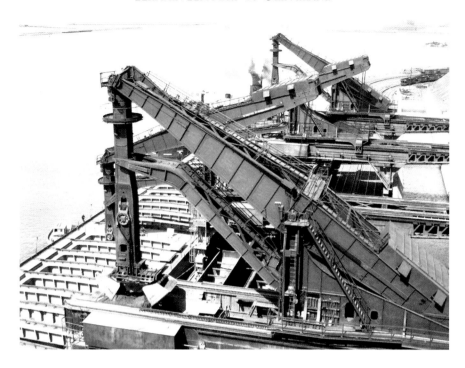

Whiskey Island were the first built and the last four remaining until 2000, when they were dismantled and demolished. At the time of demolition, two were saved, for the possibility that one might be reconstructed.

A set of fifteen four- by five-inch transparencies was created by Jack Delano in May 1943. It is part of the Farm Security Administration/Office of War Information Collection, currently available in the American Memory Project at the Library of Congress. There, you can download massive 140-megabyte tiff files of these transparencies.

We see the scoop of the Hulett open as it descends down into the freighter. The arm of the unloader descends all the way into the ship to scoop out the iron ore. With the scoop full, the arm lifts up out of the freighter. Finally, the ore drops into hopper cars waiting below, to go off to the steel mills.

We all should have done more to prevent the demolition of these icons of Cleveland's heroic era of heavy industry.

CARS, BEER AND THE LAW

The new Cuyahoga County Juvenile Justice Center, at the southeast corner of Quincy Avenue and East Ninety-third Street, has opened to much

Peerless Motor Company Office Building (1908), J. Milton Dyer, architect. East Ninety-third Street and Quincy Avenue, Cleveland, Ohio. Demolished. Photograph by Jet Lowe for the Historic American Engineering Record, 1979. *Courtesy of the Library of Congress.*

attention in the Fairfax neighborhood of Cleveland. In all of the publicity, though, there has been little written about the history of the site.

In 1906, the Peerless Motor Car Company, one of the finest manufacturers of automobiles in the United States, built a handsome factory there, designed by architect J. Milton Dyer. Dyer was also responsible for the Cleveland Coast Guard Station (see "Streamlined"), the Cleveland City Hall, the Tavern Club and the Brown Hoist building (see the following section). The factory stretched all the way to Woodland Avenue. While the portions of the factory between Quincy and the train tracks have been demolished, some structures remain between the tracks and Woodland.

The factory's office building faced Quincy Avenue. Dyer's work on the structure received considerable praise. Its "front of attractive design" showed the influence of Frank Lloyd Wright in the geometric stone ornament and globe-capped pylons, as well as of Art Nouveau in its metal and glass entrance canopy and doors. Architecturally, the office building was significant in its day.

Main stairway, Peerless Motor Company Office Building. Photograph by Martin Linsey for the Historic American Engineering Survey, February 28, 1966. *Courtesy of the Library of Congress.*

In 1931, Peerless closed its business, unable to find a market for luxury cars during the Depression. The business was reorganized and eventually became the Carling Brewing Company. The automobile factory was repurposed as the brewery, which operated there until 1971. C. Schmidt & Sons purchased the building and also operated it as a brewery from 1972 to 1984.

Most of the complex was demolished in 1994. The Historic American Buildings Survey has two sets of documentation covering the history of the structure and of the Peerless operations in Cleveland.

THE BROWN HOIST BUILDING: AN INDUSTRIAL LANDMARK

One of Cleveland's most interesting industrial structures is located at the northwest corner of East Forty-fifth Street and Hamilton Avenue. It's hard to convey the size of this massive building (312 by 500 feet), and its design is equally impressive.

Built in 1901–2, it was designed for the Brown Hoisting Machinery Company by J. Milton Dyer. Among Dyer's significant commissions were the Cleveland City Hall, the Peerless Motor Car factory (see the previous section) and the Cleveland Coast Guard Station (see "Streamlined").

The Brown Hoist (or Brown Hoisting) Company was founded in Cleveland in 1885. It became the largest company in the world to exclusively manufacture cranes and materials handling machinery, filling orders for all types of industry. In 1900, a fire destroyed the factory.

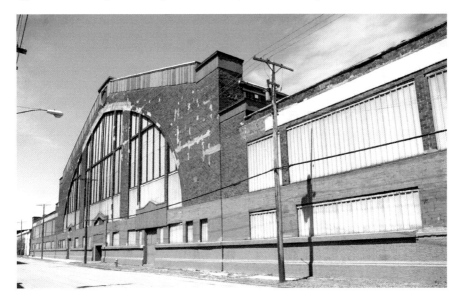

The Brown Hoist building (1902), J. Milton Dyer, architect. Hamilton and East Forty-fifth Streets, Cleveland, Ohio. *Photograph by the author, May 19, 2010.*

Soon after the fire, work began on a new, fireproof plant. As of January 25, 1901, the remains of the original structure had been condemned. It was expected to take thirty days to create the plans and another two to three months for the construction.[91] The company took the opportunity to expand its manufacturing operations, with the purchase of land on Hamilton Avenue.[92]

Alexander Brown, vice-president of Brown Hoist, worked to create a building material that was fireproof, lightweight and cheap. His process, called "Ferroinclave," was first used in this building. Eric Johannesen, in *Cleveland Architecture, 1876–1976*, described the material, which "[c]onsisted of corrugated steel sheets formed by alternating Z-angles into dovetails, covered on both sides with cement…This idea was also the origin of the steel-formed stairs with cement treads which are a part of standard building practice seventy-five years later."

In May 1901, a building permit was pulled for the new factory building, with the cost estimated at $200,000.[93] When completed, the building was to be the largest in Cuyahoga County.[94]

Dyer designed the office part of the complex as well.[95] A grand opening and dance for the office building were held on June 20, 1902.[96] The building, at 4403 St. Clair Avenue, Cleveland, still stands.

An article in the *Plain Dealer* on May 22, 1902, describes the factory building:

> *The main shop covers about 156,000 square feet of ground, constituting one large room without a single partition. The roofs are supported by heavy steel columns placed at intervals of about forty to seventy feet. The shop is composed of seven compartments or bays, each of which is equipped with huge traveling cranes of twenty to thirty tons capacity. The entire structure has a floorspace fully double that of the old shop and it is estimated that with the largely increased facilities the annual output of the company will be three times as large as formerly…*
>
> *The plant is lighted by electricity, which power is also utilized in propelling the great cranes, and an improved system of heating and ventilating by underground conduits has been installed.*

Eric Johannesen called the Brown Hoist building a "landmark in both structure and architecture" in *Cleveland Architecture*. Mary-Peale Schofield, in *Landmark Architecture of Cleveland*, said that it was "[a]s striking today as it was in 1906."

The building is an industrial warehouse today.

THE NEW CUYAHOGA: A PROPOSAL TO STRAIGHTEN THE "CROOKED RIVER"

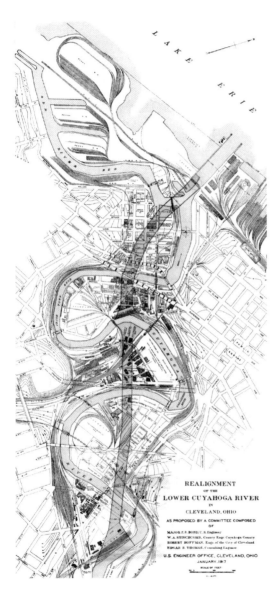

REALIGNMENT
OF THE
LOWER CUYAHOGA RIVER
IN
CLEVELAND, OHIO

AS PROPOSED BY A COMMITTEE COMPOSED
OF

MAJOR F.S. BOND, U.S. Engineer
W.A. STINCHCOMB, County Engr. Cuyahoga County
ROBERT HUFFMAN, Engr. of the City of Cleveland
EDGAR B. THOMAS, Consulting Engineer

U.S. ENGINEER OFFICE, CLEVELAND, OHIO
JANUARY, 1917

SCALE OF FEET

Realignment of the Lower Cuyahoga River in Cleveland, Ohio, as illustrated in "The New Cuyahoga" (1917). *Courtesy of Special Collections, Cleveland State University.*

The name "Cuyahoga" is said to come from a Mohawk word meaning "crooked river." Yet in the 1910s, there was a proposal to straighten the river, *The New Cuyahoga: River Straightening Recommendations*. This document was brought to my attention by Kevin Leeson of the Cuyahoga County Planning Commission.

The publication includes a folded map, with blue color representing the current looping course of the river and red slicing off the bends and curves in the proposed realignment. Why would the Committee on River and Harbor Improvement of the Cleveland Chamber of Commerce suggest this? Why would members propose drastic change to one of the signature elements of our city?

In short: commerce. The report notes that the difficulty of navigating the river made shipping to and from Cleveland more expensive, putting the port at a commercial disadvantage. Further, the report argues that the project would provide relief from

the flooding of the Flats, as had happened in 1904 and 1913. Helpfully, the report suggests that the money saved by preventing floods would cover the cost of the river realignment and that it would open part of the upper Cuyahoga to industrial development. There's no mention as to whether they planned to change the name of the river, once it was no longer "crooked."

Proposals to straighten the river show up from time to time, even in recent years, but they have remained mere proposals. The last major change was in 1827, when the final, long, winding bend of the river was cut off, creating a more efficient channel to the lake and isolating the land that we now call "Whiskey Island." The shape of the river is an important part of Cleveland's history and heritage.

THE DAY-GLO HOUSE

As I was reading *The Day-Glo Brothers*, a children's book about the invention of Day-Glo paints, I was excited to discover that the invention happened in Cleveland. There was one passage that particularly caught my eye: "After Joe got married in 1938, he and his wife, Elise, moved into a run-down old farmhouse so that he would have room for his own laboratory." On the following page, we learn that soon after, they figured out how to make lightfast Day-Glo pigments. The Day-Glo brothers were Robert and Joseph Switzer.

A house in Cleveland where an important invention occurred? I had to find it! I searched the county recorder's property records, but the first transfer I could find for Joseph Switzer was in 1941. In that year, he moved to 1003 Elbon Road, a new house in Cleveland Heights, possibly as a result of the success of his invention. I checked some other sources, without any luck.

Finally, I e-mailed the author of *The Day-Glo Brothers*, Chris Barton, who responded helpfully, providing me with contact information for the Switzer family. But as soon as I pressed "send," it also occurred to me: why not check the most obvious source—city directories for the 1930s!

I called the History and Geography Department at Cleveland Public Library. In a matter of minutes, the librarian informed me that, in 1939 and 1940, the address for Joseph Switzer was listed as 1592 Crawford Road.

A quick check found that the house that had been at that address was no longer standing. I was pretty sure that the area was covered in the set of photos of Hough that I had digitized from property cards in the Cuyahoga County Archives, but I couldn't find the address among the group. The

property cards are a set of documents created in two series, the 1930s and the 1950s, to document all of the houses in the county for tax valuation purposes. They detail the amenities of each house, which enables us to see how the house may have changed over time.

I was suspicious about the presence of a structure described as a "farmhouse" in that area—it is always hard to think of a farmhouse in the city—though I shouldn't have been since Crawford Road existed before 1852.

I searched Sanborn Fire Insurance Maps for Ohio, a database provided through Cleveland Public Library, using the closest cross streets. Crawford Road is not labeled on the page I received, but the house was there. It is sited farther back from the road than the neighboring houses, consistent with a house built before the rest of the neighborhood. With the map showing the outline of the houses, I started looking at the property card photos again.

I was able to verify that parcel 107-17-027 was 1600 Crawford Road. Sometimes it is hard to match parcel numbers with addresses. Fortunately, the photo for each parcel often has, as here, a small part of the house in the next parcel. Following down the street, parcel 107-17-025 is 1598 Crawford, and far back from the road, we can see the neighboring house: 1592 Crawford!

The house (circa 1870) where Day-Glo pigments were invented, 1592 Crawford Road, Cleveland, Ohio. Demolished. Unknown photographer, 1959. *Courtesy of the Cuyahoga County Archives.*

In the photo for parcel 107-17-024—1592 Crawford Road—you can't see the neighbor's houses, but it is the same house that we can see in the photo of 1598 Crawford. And it matches exactly the footprint shown on the Sanborn map.

It could definitely be described as a "run-down old farmhouse," appearing as if built between the 1850s and 1870s. Clinching the identification is a brick structure at the rear of the lot, on which there is a sign that reads "Laboratories." It was described in a real estate ad as a "completely equipped experimental shop, brick and concrete construction; shop approximately 1,800 sq. ft."[97]

The laboratory structure was already present when Switzer began renting here. Earlier, it had either been built or used by E.K. Hill Jr., a food scientist.[98]

Chris Barton helped me contact a descendant, Fred E. Switzer, who was kind enough to provide information from an oral history recorded by Elise Switzer in 1991: "At a certain point, when it was really bad, Joe and Bob wanted to have the lab work, where Joe was inventing stuff, separate from the Continental Lithograph Company and Forbes Ink so that they could claim shop rights, or something like that. There was an old house on Crawford Road; it was a terrible old house." She described the exterior, saying, "The last time it had been painted was fifty years before, and they had painted it silver, if you can imagine. I mean aluminum."

When I started looking for the Day-Glo house, I was hoping to find the house standing, if for no other reason than it would be fun to paint it in Day-Glo colors.

On the corner of Lexington Avenue and East Sixty-sixth Street, in the Hough neighborhood of Cleveland, sits a landmark so big and so important that it's hard to believe that it's almost completely forgotten. It's the remains of a baseball stadium, but the field is now most often used for football.

League Park, a nine-thousand-seat baseball stadium, opened in 1891. Cy Young was pitching for the Cleveland Spiders. In 1909, the structure present today expanded the capacity to twenty-nine thousand. It remained the home of Cleveland's professional baseball teams until 1947. In 1951, the decaying seating was torn down and the space made a city park. The field remains, as does the ticket building and a section of wall.

Babe Ruth hit his 500th home run here. Satchel Paige, one of the greatest pitchers of all time, played on this field. Today it sits mostly forgotten. Money has been appropriated to restore what remains of this historic field.

I look forward, in a few years, to going down here with my son and playing catch on the same ground that so many great athletes have trod. There isn't another standing professional stadium where one can do this.

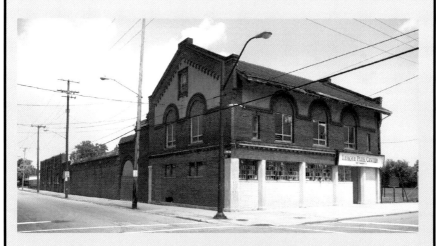

League Park (1910), Osborn Engineering, architect, 6601 Lexington Avenue, Cleveland, Ohio. *Photograph by the author, June 28, 2011.*

Part IV

SPORTS

THE LARGEST CROWD FOR A BASEBALL GAME: WHITE AUTOS V. OMAHA LUXUS

I was browsing through the American Memory collection at the Library of Congress when I came across a series of five panoramic photographs of baseball games at Brookside Stadium in Cleveland. Three were of a 1915 championship game between the White Autos and the Omaha Luxus; one was of a 1915 game between the White Autos and Johnstown, Pennsylvania; and one was of a 1914 game between Telling's Strollers and Hanna's Cleaners.

The October 10, 1915 amateur championship game between the White Autos and the Omaha Luxus attracted the largest crowd for any baseball game ever, if crowd estimates of 115,000 are accurate. From the photographs, the estimates are certainly believable. The stadium was located in a natural bowl, with spectators filling the hillsides. And the crowd was able to go home cheering—the local White Autos won, 11–6.

I had never heard of the stadium, so I started looking for it. It seemed likely that Brookside Stadium was somewhere near the current Brookside Metropark, but I was not sure exactly where. I found the answer in the 1922 *Plat Book of the City of Cleveland*. Brookside Stadium appears in the upper corner of one map, just south of Denison Avenue, between Fulton Road and West Forty-sixth Street.

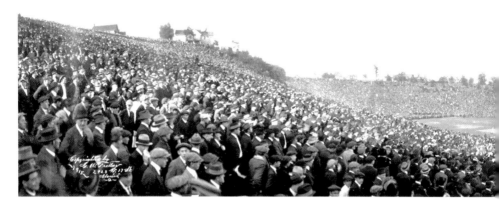

Championship baseball game, between the White Autos and the Omaha Luxus, Brookside Park, Cleveland, Ohio. Photograph by Gus A. Fretter, October 10, 1915. *Courtesy of the Library of Congress.*

The stadium shown on the map didn't seem to correspond to what I could see in the photographs. Then I looked at contemporary aerial photographs of the site, and much to my surprise, I saw that there was still a baseball diamond! The topography of the space is relatively unchanged—it still has the nice "bowl" shape that made it a perfect stadium. There are now trees growing on the hills, but other than that, the shape of the land remains much as it was in 1915.

The stadium is located just south of Denison Avenue, between Fulton Road and West Forty-sixth Street. The diagonal line of people in the outfield is Fulton Road, from the time before it had a high-level bridge over the valley.

The amateur Omaha Luxus team was sponsored by Krug Brewery in Nebraska. Luxus was one of their beers. The White Autos were sponsored by White Motor Company, a manufacturer of trucks and automobiles.

The Cleveland Naps occasionally used Brookside Park Stadium. They changed their name from the Cleveland Blues in 1903 to honor their second baseman, Napoleon "Nap" Lajoie, perhaps the greatest baseball player of his time. In 1915, the team changed its name to the Cleveland Indians.

I'm happy that this piece of Cleveland history is still here. I knew that we had one historic baseball playing field in League Park. I didn't know that we had two. Both ballparks are places where a group of neighborhood kids can play a game of ball on the same ground as the great players of the past.

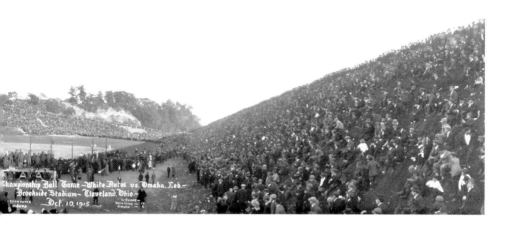

THE PITCH THAT KILLED

At the start of each baseball season, we remember Raymond Johnson Chapman (January 15, 1891–August 17, 1920), who was killed by a pitched ball—the last professional baseball player to die from an injury in the course of a game. The pitch, thrown by Carl Mays, occurred during a game between the Cleveland Indians and the New York Yankees at the Polo Grounds in New York. Chapman played for the Indians for his full career, 1912–20.

His funeral was at St. John's Cathedral, and he is buried at Lake View Cemetery. A historical marker, erected by the Lake View Cemetery

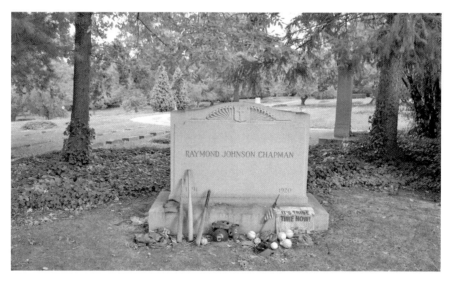

Grave of Raymond Chapman, Lake View Cemetery, Cleveland, Ohio. *Photograph by the author, September 28, 2008.*

Association, commemorates his life. The cemetery is located between Euclid and Mayfield Roads in Cleveland.

The Pitch that Killed by Mike Sowell documents the story behind this tragedy.

The Jesse Owens House

I was browsing photographs from the Cleveland Press Collection, part of the Cleveland Memory Project at Cleveland State University, and came across an interesting image that initiated an investigation. The image, taken in 1935, shows the athlete Jesse Owens seated in front of his house. The photograph was presumably taken for a newspaper story reporting the Big Ten track meet in Michigan in which Owens set three world records and tied a fourth in the space of forty-five minutes. The next year, at the 1936 Olympics in Berlin, Owens won four gold medals.

I asked the Cleveland State University Special Collections librarian, Bill Barrow, to send me a high-resolution version of the file to help me identify the location of the house. Half an hour later, I received an e-mail from Mr. Barrow with an address: 2178 East 100th Street.

The next morning, I drove down East 100th Street and found the house still standing. It is presently occupied as a rental property. It has suffered the indignity of vinyl replacement windows and vinyl siding but otherwise looks in solid condition.

I asked Michael Ruffing, a librarian in the Department of History and Geography of Cleveland Public Library, to check Cleveland city directories to see if we could figure out when Owens lived there. The directories show him at this address from 1934 to 1936—the most important years of his career.

The continued expansion of the Cleveland Clinic is a threat to this house. The clinic has shown its feelings for historic preservation in the demolition of the Art Deco Ohio College of Podiatric Medicine building to make way for surface parking. A medium-sized building was recently completed just across the street from the Jesse Owens house. It might be only a matter of time before this house is put on the Clinic's demolition list.

This house should be a Cleveland Landmark—it was the residence of one the most significant athletes of the twentieth century at the height of his athletic career. If the interior remains relatively original, it should be considered for National Historic Landmark status.

There are two other addresses associated with Jesse Owens in Cleveland that are identified by the city directories: he lived at 2020 Hamilton Avenue

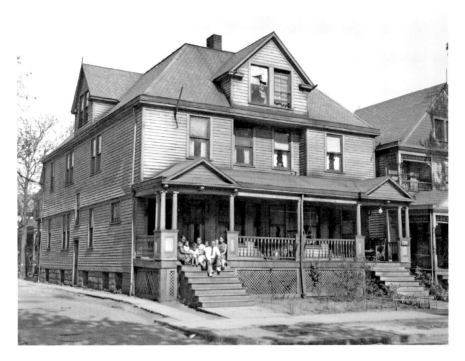

The home (circa 1890) of Jesse Owens, track star, at the peak of his career in 1934–36, 2178 East 100th Street, Cleveland, Ohio. From the Cleveland Press Collection. *Courtesy of Special Collections, Cleveland State University.*

from 1924 to 1926 and at 2212 East Ninetieth Street from 1927 to 1929. The 1930 census also places Owens at the East Ninetieth Street address. There are no listings for the Owens family in the city directories from 1930 to 1933. The structure at 2020 Hamilton Avenue has been demolished; the house at 2212 East Ninetieth Street still stands.

THE BIRTHPLACE OF JOHN W. HEISMAN

I'd long heard a rumor that the Ohio Historical Marker for the John W. Heisman birth site was located in front of the wrong house and that the error had occurred due to a change in the street addresses in Cleveland at some time in the early twentieth century. Heisman (1869–1936) was an innovative football coach, and the Heisman Trophy—which is given annually to the best collegiate football player—was named to honor him. The house is in the Ohio City neighborhood of Cleveland, on the near west side. The marker is in front of a 1910s Cleveland duplex on Bridge Avenue, at West Twenty-ninth Place,

Birthplace of John W. Heisman (circa 1850), 3928 Bridge Avenue, Cleveland, Ohio. *Photograph by the author, April 14, 2009.*

where it has been for the past thirty years. I decided to do the legwork to determine whether this was, in fact, the site of Heisman's birth.

The Cuyahoga County Recorder maintains a database of all real estate transfer documents dating back to the early nineteenth century. I was able to locate a deed transferring a property to the Heismans, which included a specific lot number. Utilizing historical maps, I was able to find the house that the Heismans purchased. The birthplace is, in fact, four-tenths of a mile to the west, at 3928 Bridge Avenue.

Architecturally and historically, this house is more interesting, as the main part of it was built in the 1850s. This means that it is the actual house in which John Heisman was born, rather than merely the house on the site of his birthplace.

Shortly after I purchased the ten glass plate negatives that I used in the section "Views of Cleveland, 1927," I purchased another group of photographs on eBay, one that I hoped had similar promise.

These fifty-two snapshots seem to have all been taken between 1910 and 1913. While an interesting collection, they don't feature the landmarks that make for easy identification. I've been able to assemble something of a narrative, but it doesn't seem to be a story that merits being spread out over several sections. I've shared the best of the lot here. I hope that if you find them interesting, you'll look at the full set. Perhaps you'll be able to illuminate more of the story. The entire set can be seen online, on the Cleveland Area History blog.

As snapshots, likely made with inexpensive cameras, the quality of the exposure of the originals varied considerably. I have adjusted the exposure as needed to provide the greatest possible level of detail. They had been removed from an album prior to coming into my possession. They retain fragments of the adhesive corners used to hold them into the album.

Group portrait (snapshot). Unknown photographer, circa 1910. *Collection of the author.*

Above: Three East Tech students (or recent graduates), probably on Sagamore Avenue, Cleveland, Ohio. Unknown photographer, circa 1910. *Collection of the author.*

Below: Portrait of a woman, backyard of 7608 Sagamore Avenue, Cleveland, Ohio. Unknown photographer, December 25, 1910. *Collection of the author.*

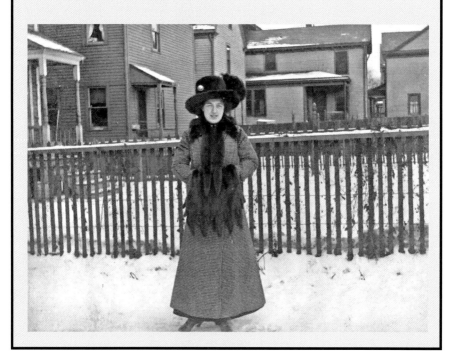

Many of the photos are group portraits. There are often two versions of the same composition. Some appear to have been more candid, or at least attempting to look more candid.

These three women appear to be East Tech students or recent graduates. They would likely have been in one of the first graduating classes, as the school opened in 1908. The location of the photo may have been on Sagamore Avenue. Other photos in the set illustrate the winter landscape on that street.

A woman, who appears in several of the other photos, was photographed in the backyard of 7608 Sagamore on Christmas Day 1910. The rear portion of the house that is visible immediately to her left, 7702–7704 Sagamore, was moved to the site between 1903 and 1910 from the southwest corner of Sagamore and East Seventy-ninth Street. The address, pre-1905 (and pre-move), was 968 East Madison.

The landscape of Gordon Park features prominently in several of the photos, many of which were taken in the winter. A structure that appears to be a bathhouse is visible in the background.

A few of the photos are of a camping trip. One guess as to the location would be the Cuyahoga Valley, but it could be any number of other locations as well.

This collection provides a look into a group of upper-middle-class young men and women from about 1910–13.

Part V

NOTABLE PEOPLE

JAMES A. GARFIELD SLEPT HERE

The house at 4400 Turney Road in Cleveland caught my attention, but my interest was really spurred when I came across an image of it in *Recollections: A Collection of Histories and Memories of Garfield Heights*, published by the Garfield Heights Historical Society in 2003.

This house, built about 1850, was the residence of Thomas Garfield from 1850 to 1873. Garfield was the uncle of President James A. Garfield. In *Recollections*, Dan Ostrowski noted, "James Garfield spent a great deal of time at his uncle's home during his studies at Hiram [College] and most likely during his one season job on the Ohio and Erie Canal." Garfield was a student at Hiram College from 1851 to 1854.

A historic photograph, published in *Recollections*, shows how the house has been changed. At that time, it was not uncommon for a house to have two front doors. Comparing with the historic photograph, the door closer to the street is missing, now covered by vinyl siding. Sometimes, when installing vinyl siding, a feature might not be removed—just covered up—so the door might still be present.

It's things like this that firmly cement my belief that history isn't something that happens elsewhere, on grand avenues and in great buildings. History is something that happens right here, in our neighborhoods, on the streets we walk every day.

The Thomas Garfield residence (circa 1850). James A. Garfield spent at least one summer here, between 1851 and 1854, 4400 Turney Road, Cleveland, Ohio. *Photograph by the author, July 9, 2011.*

BREAKING THE COLOR LINE: CHARLES W. CHESNUTT

Noted author and lawyer Charles Waddell Chesnutt was born in Cleveland on June 30, 1858. He was the first African American to have a novel—*The Conjure Woman* (1899)—issued by a major publisher. Principal concerns of the book were issues of race and equal rights. He continued working with these themes in his other books: *The Wife of His Youth and Other Stories of the Color Line, Frederick Douglass, The House Behind the Cedars, The Marrow of Tradition* and *The Colonel's Dream.*

Chesnutt lived in the house (circa 1885) at 9717 Lamont Avenue from 1904 until his death in 1932. The site is just down the street from the (now missing) historical marker honoring him. The house was demolished to make way for Charles Orr Elementary School. The Cleveland Public Library has a collection of photographs relating to Chesnutt, his life and this house.

His previous residence, from 1888 to 1904, was 64 Brenton Street, which is now 2212 East Seventy-third Street. His personal library in that house can be seen in some of the photographs in the collection of Cleveland Public Library.

The residence (circa 1890) of author Charles W. Chesnutt from 1904 to 1932, 9717 Lamont Avenue, Cleveland, Ohio. Demolished. Unknown photographer, 1907. *Courtesy of Special Collections, Cleveland Public Library.*

THE WILLIAM HOWARD BRETT HOUSE

William Howard Brett (1846–1918), head librarian of Cleveland Public Library from 1884 to 1918, lived at 2250 East Forty-ninth Street in Cleveland. Brett was a prominent educator in the field of library science. He was dean

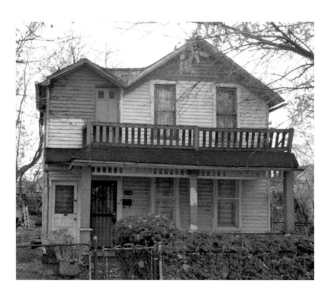

The residence of librarian William Howard Brett (circa 1875), 2250 East Forty-ninth Street, Cleveland, Ohio. *Photograph by the author, February 25, 2009.*

of the library school at Western Reserve University and was president of the American Library Association in 1896.

Among his contributions to American libraries was his advocacy for the concept of open shelving of books. Before this time, books in libraries were usually kept in closed stacks—patrons had to request and then wait for the individual books that they wanted. A special issue of the *Open Shelf*, a publication of the Cleveland Public Library (September–October 1918), provides a detailed memorial of his life.

This house should have a historical marker, sharing the story of its prominent resident.

Langston Hughes: His Attic Apartment

Langston Hughes was among the most important American writers of the twentieth century, known for his novels and plays and especially for his poetry, first capturing attention with his moving "The Negro Speaks of Rivers." He spent formative years in Cleveland, but the places in which he lived have sat unrecognized for decades.

In the summer of 2009, as I was preparing programming for a day camp, I started researching to find important and famous people who had lived in the neighborhoods surrounding the library in which I worked. It's easier to teach history when you can talk about things that happened in the places where the kids live, on the streets that they walk every day.

Everyone suggested that I find the home of Langston Hughes, but no one really knew where he had lived. Thanks to the research and resources of the Literature Department at Cleveland Public Library, I was able to discover the house at 2266 East Eighty-sixth Street, one of only two surviving places in Cleveland where Hughes lived. The house had been foreclosed and faces the threats that every boarded-up property faces: vandalism and eventual demolition.

Jay Gardner, community development director at Fairfax Renaissance Development Corporation, was kind enough to show me through the historic house, located in his neighborhood of Cleveland. Writer, poet and playwright Langston Hughes lived alone in an attic apartment here from 1917 to 1919, during his sophomore and junior years at Central High School.

Hughes's stepfather and mother had left for Chicago in search of work, leaving him behind. During his residence here, he met Russell and Rowena Jelliffe, founders of Karamu, a settlement house where Hughes taught art to children and where some of his plays would later premiere. It was while

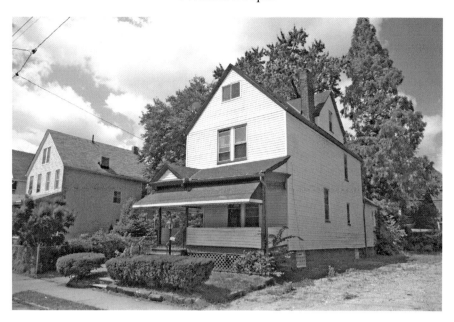

Langston Hughes lived alone in an attic apartment in this house (circa 1890) during his sophomore and junior years of high school, 2266 East Eighty-sixth Street, Cleveland, Ohio. *Photograph by the author, July 16, 2009.*

he was living on East Eighty-sixth Street that he really began to pursue writing—he joined the staff of the high school literary magazine, in which his early writing was published.

The attic, which consists of two rooms, retains very little, if any, of the physical fabric present when Hughes called it his home. The trim and doors in the front room are relatively recent, as are the electric baseboard radiators. When the house was built, this space was probably unheated—the rest of the house is heated by forced air. The second floor has three bedrooms and a bathroom, joined by a long hallway. At the end of the hall are the stairs going up to the third floor. The remains of a gas lamp can be seen on the wall in the hall. The baseboards and molding around most of the door frames are original, as are several ornate furnace registers.

On the first floor, the kitchen is located in a small addition at the rear of the house. As with many foreclosures, it has suffered some vandalism. The kitchen addition was built before 1936, as it is included on the floor plan on the property card dated that year. Further, the property card does not mention a date for the house being remodeled, which suggests that the addition was not recent at that time. In his first autobiography, *The Big Sea*, the only mention Hughes gives of his place of residence is this passage:

I couldn't afford to eat in a restaurant, and the only thing I knew how to cook myself in the kitchen of the house where I roomed was rice, which I boiled to a paste. Rice and hot dogs, rice and hot dogs, every night for dinner. Then I read myself to sleep.

The dining room retains the original moldings and trim. The living room is trimmed in a manner similar to the dining room. The molding includes a picture rail. A beautiful railing graces the staircase on the north edge of the living room.

To learn more, I went to the Cuyahoga County Archives, where I investigated the property cards. Both property cards, dated October 1936 and July 1959, note that the attic was unfinished. There was a floor present, but that was it—the space was used for storage. This information could be taken at face value, but it is possible, since this information was partially owner-reported, that the owner was trying to get the lowest possible tax valuation. The property cards also both note that there was only one bathroom, which was not correct.

A photograph taken in July 1959 reveals a bit more than is visible today. The house had a slate roof and half-round gutters. There's interesting trim between the second and third floor and an attractive bay window.

I wonder how much his experience in this house shaped Langston Hughes. Would he have spent so much time reading, writing and learning if he had been in more comfortable surroundings? Would he have made so many important friendships? How did this experience affect the man he became?

DESIGNING HISTORY

I.T. Frary was one of the pioneers of the historic preservation movement. He wrote the first book on historic buildings in Ohio and was responsible, on a national level, for an appreciation of Ohio's architectural heritage. His photograph collection at the Ohio Historical Society is a phenomenal archive of early Ohio architecture. As an artist, he's the only Clevelander to have major bodies of his work exhibited at the National Gallery of Art in Washington, D.C., and the Metropolitan Museum of Art in New York while a resident of Cleveland.

Ihna Thayer (I.T.) Frary was born in Cleveland in 1873. He attended the Cleveland School of Art (now the Cleveland Institute of Art), with his studies focused heavily on architecture.

I.T. Frary residence (circa 1910), 2225 Bellfield Avenue, Cleveland Heights, Ohio. Frary lived in this house from 1920 to 1946. *Photograph by the author, July 9, 2011.*

In 1894, he began working as a designer for the Brooks Household Art Company, an interior design firm that eventually became the other half of the Rorimer-Brooks Company. By 1905, Brooks had done significant projects in more than a dozen of the grand homes that once lined Euclid Avenue in Cleveland. From 1909 to 1911, it did more than $25,000 worth of work for Samuel Mather's Euclid Avenue mansion. Eventually, Frary became the lead designer, and he remained with the firm until 1914, when he began to work as an independent designer.

Frary was a member of the Cleveland Architectural Club and served as its vice-president. There he developed friendships with Louis Rorimer and William Bohnard, an architect Frary would later work with on the Historic American Buildings Survey (HABS). He became a frequent contributor to *Architectural Record*.

On June 2, 1904, I.T. Frary married Mabel Guild. A sketchbook in the possession of Susan Frary Winkler illustrates their honeymoon and the months that followed. Among the drawings is one of the H.A. Smith house, in Adams Mills, Ohio, where his wife's family lived. Adams Mills is a recurring subject in Frary's work.

In 1920, he became membership and publicity secretary at the newly opened Cleveland Museum of Art. He began photographing historic

buildings on weekend outings in the family car, which soon became a major interest, resulting in lectures, activism in historic preservation and the publication of the first book on Ohio's architectural heritage.

At the time I.T. Frary began taking photos of old buildings, the houses in which he was interested were half as old as they are now. Even so, many of them were on the brink of destruction. Frary was a rare voice, and his eloquent presentation, combined with his beautiful photographs, made his lecture "Early Homes of Ohio" quite popular, nurturing public interest. The book *Early Homes of Ohio*, published in 1936, was the first to document the state's architectural heritage. The photographs—more than two hundred—are of the highest quality, contributing to the warm reception of the book. It's important to keep in mind that when Frary started taking these photographs in 1920, people weren't interested in the architectural heritage of this state, with the possible exception of the grandest homes. If you look at Ohio tourist brochures from the 1910s and '20s, the only mention of historic buildings is when they were associated with famous people. Further, interest in historic architecture in the United States was mostly limited to the East Coast. Many people thought that architecture in Ohio was simply too new to be historic.

Nationally, Frary is best known for the book *Thomas Jefferson, Architect and Builder* (1931), the first book about Jefferson as an architect. In it, too, Frary's beautiful photographs helped show the need for preservation.

VIEWS OF CLEVELAND, 1927

On eBay, I bought ten four-by-five-inch glass plate negatives of Cleveland that were taken about 1927. They appealed to me because they were personal photographs, so they weren't the same scenes from the same angles that I've seen so often from professional photographers. Some were of areas that I haven't seen photographed. Also, the large negatives contain a heck of a lot of information. You can read street signs, billboards and signs in store windows.

I thank Bill Barrow, Special Collections librarian at Cleveland State University, and the fine folks in the Digital Production Unit for helping me to identify the locations of these images.

The following is a selection from that set. The full set may be found on the Cleveland Area History blog.

Carnegie Avenue (then Central Avenue) and East Fourteenth Street, looking northwest. To the left is St. Anthony of Padua Roman Catholic

Carnegie Avenue and East Fourteenth Street, looking northwest, Cleveland, Ohio. Unknown photographer, circa 1927. *Collection of the author.*

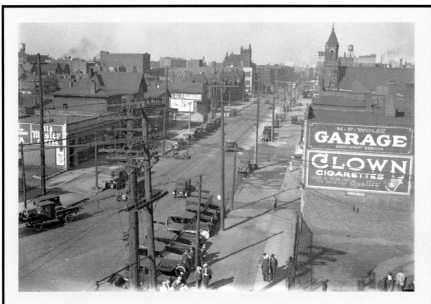

Above: Looking southwest on Carnegie Avenue from East Fourteenth Street, Cleveland, Ohio. Unknown photographer, circa 1927. *Collection of the author.*

Below: Looking southwest on Carnegie Avenue toward Woodland and Broadway Avenues, Cleveland, Ohio. Virtually all of the buildings have been demolished. Unknown photographer, circa 1927. *Collection of the author.*

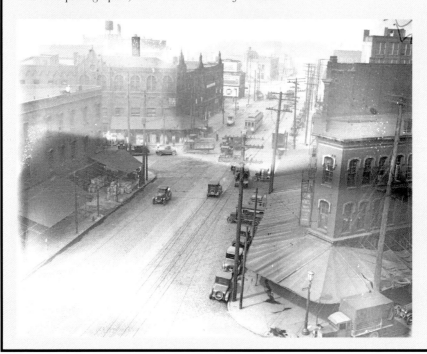

Church, which is still standing. Next to it is the May Company garage; behind them, a bit of open space—Erie Street Cemetery; and behind the first row of buildings, Brownwell Junior High School, also still standing. On the same block, we can also see H.F. Wolff's garage and a Rex gas station.

On another corner, there is a tailor, print shop, and restaurant. On East Fourteenth Street, on the far left, is a building with decorative elements with characteristics of Art Nouveau.

Carnegie Avenue from East Fourteenth Street, looking west. The sign of H.F. Wolff Garage is on the right. Also visible are the spires of St. Anthony of Padua. Just about all of the other buildings shown here—houses and commercial establishments—are now gone.

This view, still looking northeast, shows the intersection with Broadway. The tower of Acme Hall is visible just behind the traffic light, in the middle of the intersection. The water tower of the coffee company can be seen here. Finally, the Botzum Bros. sign that was visible in the previous photograph can just be seen above the far end of the streetcar. Note the interesting truck on the right, on Broadway, just about to pull onto (or across) Central.

Part VI

Notable Buildings

The Schofield Building, Undressed

Many of the office towers that were built in downtown Cleveland in the late nineteenth and early twentieth centuries received steel and glass façades in the 1950s, '60s and '70s that made them appear to be more recent structures and hid any clue as to their historical appearance. The Schofield Building was one of the buildings to be "dressed up."

Prominent at the southwest corner of Euclid Avenue and East Ninth Street, it was built in 1901. The architect was Levi Scofield (originally "Schofield"), who was also responsible for the Soldiers' and Sailors' Monument on Public Square.

The building never made a significant impression on me. It looked like a generic office tower built in the 1970s or 1980s.

Imagine my surprise when I saw the façade being removed above while walking down East Ninth Street to a recent Landmarks Commission meeting. Most of the façade had been removed, revealing Corinthian columns on the corner and handsome detail around the windows.

According to an article published on Cleveland.com on June 8, 2009, the investors who own the building received a $1.25 million loan from the City of Cleveland to remove the coverup and determine the original appearance of the building. This is the first step in applying for state and federal historic preservation tax credits.

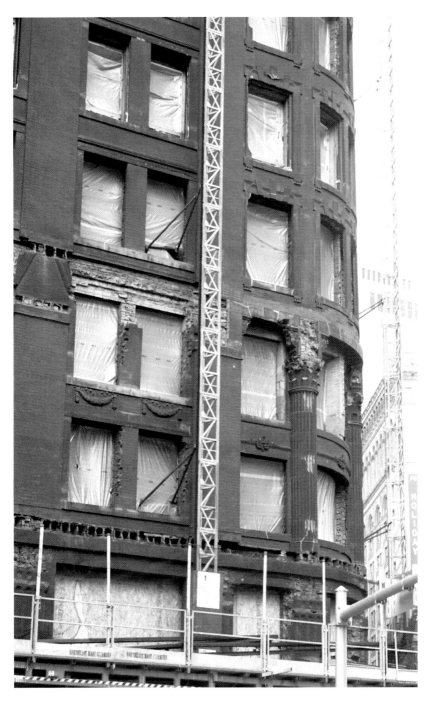

The Schofield Building (1901), Levi Scofield, architect. 2000 East Ninth Street, Cleveland, Ohio. *Photograph by the author, April 22, 2010.*

The Bare Bones of Severance Hall

Sometimes you come across a group of photographs that gives you a new perspective on something you think you know reasonably well. This happened when I stumbled across a collection of photographs of Severance Hall on Flickr. Severance Hall, a commanding presence on Euclid Avenue in the University Circle area of Cleveland, was built to be the home of the Cleveland Orchestra.

The photographs are from a book, *Severance Music Hall,* that is in the Special Collections at Cleveland Public Library. The architects of Severance Hall, Walker and Weeks, are the authors. The volume illustrates the construction, from excavation of the foundation in November 1929 to the completion of the basic structure in August of the following year. It does not proceed to the finish work or interior details, but there are plenty of photos elsewhere of the glorious interior.

The first image is of the vacant lot where Severance Hall will be built. The excavation of the foundation has already begun, yet some debris remains to be cleared. In the distance, slightly to the left of center, is Amasa Stone

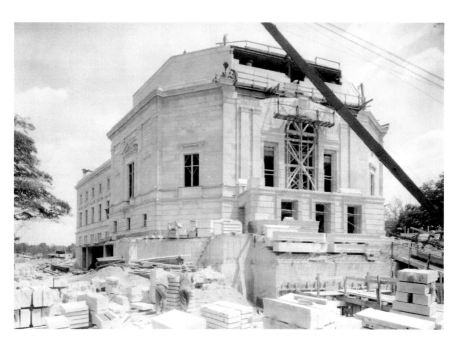

Façade of Severance Hall (1931), Walker and Weeks, architects, 11001 Euclid Avenue, Cleveland, Ohio, June 5, 1930. *Courtesy of Special Collections, Cleveland Public Library.*

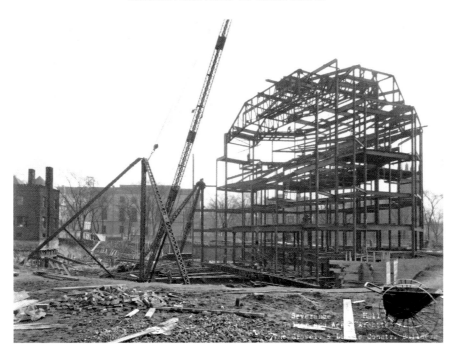

Steel framework for Severance Hall, looking toward the Allen Medical Library, February 20, 1930. *Courtesy of Special Collections, Cleveland Public Library.*

Chapel, completed in 1911. Behind the trees to the left, in the distance, is the Cleveland Museum of Art. On the right are two structures: Thwing Center of Case Western Reserve University and the top of the tower of the Church of the Covenant.

The construction progresses to a photograph dated February 20, 1930. For the first time, we see the basic shape that we know as Severance Hall. It is surprising how early in the construction that the landmark form of the structure is recognizable.

The photos also document the building of the interior, and it is possible to visualize the soaring space of the main hall within the steel framework.

At first glance, the photos appear almost like snapshots. Then you realize that, if so, they are very lucky snapshots. Closer examination reveals real care in composition, as well as the use of a view camera, revealed in the carefully aligned verticals.

A view of work on the roof, dated June 17, 1930, seems a change in style from the vertical emphasis of so many of the rest of the photos. In the distance, to the right, is the Church of the Covenant and the apartment building at the corner of Ford Drive and Euclid Avenue.

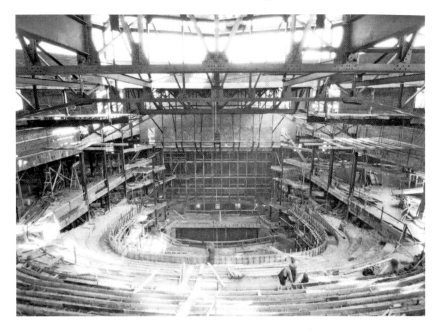

Interior of Severance Hall, May 22, 1930. *Courtesy of Special Collections, Cleveland Public Library.*

My favorite is a photograph with the sun low in the sky, providing a beautiful source of illumination. If you just look at the steel framework, you might think that it was a recent construction project. The style of the workers' trucks and the construction machinery are the only things that give away the date.

THE FIRST CLEVELAND CLINIC BUILDING

An off-white four-story brick building, on the south side of Euclid Avenue at East Ninety-third Street, was the original home of the Cleveland Clinic.

It is important as a landmark in the development of one of the most important medical institutions in the world, and it is also the site of one of the worst disasters in the history of Cleveland. An incandescent light bulb ignited nitrate-based X-ray film on May 15, 1929, killing 123 people. Almost all of the deaths were the result of poisonous gasses released by the burning of the film.

The Cleveland Memory Project has resources on the fire, including the report from the National Board of Fire Underwriters that investigated the disaster. The fire led to stricter regulations regarding the construction of medical buildings and new standards for the storage of film.

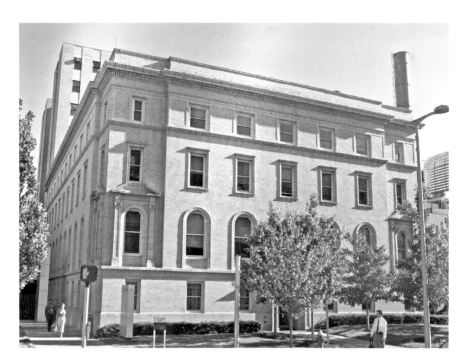

The first Cleveland Clinic building (1921), Euclid Avenue at East Ninety-third Street, Cleveland, Ohio. *Photograph by the author, June 29, 2011.*

The Cleveland Clinic has long been a leader in medical research. It is one of the top hospitals in the country—and in some fields, the world. From this beginning it grew to the giant it is today.

The Cleveland Clinic clearly has some respect for historic buildings, contrary to what recent demolitions might suggest. Administrators had the ability and the resources to repurpose ninety-year-old structures to fit contemporary needs. Perhaps the clinic will be able to apply the same ingenuity with the Cleveland Play House building, designed by Philip Johnson, which it recently purchased (see "The Last Act for Johnson's Cleveland Play House").

CLEVELAND'S CRYSTAL PALACE

There are quite a few great public interior spaces in downtown Cleveland, which makes sense for a city with a long, gray winter. The best of these interior spaces, and one of the very best interior spaces in the United States, is the Old Arcade.

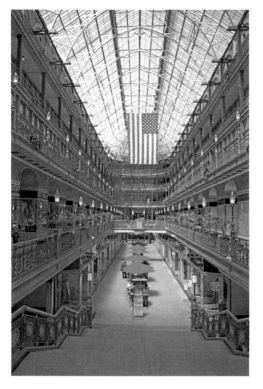

The Arcade (1890), George H. Smith and John Eisenmann, architects, 401 Euclid Avenue, Cleveland, Ohio. *Photograph by the author, April 11, 2009.*

The Arcade, a National Historic Landmark, runs between Euclid Avenue and Superior Avenue. It was designed by George H. Smith and John Eisenmann and was completed in 1890. Once known as Cleveland's Crystal Palace, it was created as a shopping center, with offices on upper floors. The Euclid Avenue entrance is a floor higher than the Superior Avenue entrance, which effectively creates two main floors.

The Historic American Building Survey (HABS) explains the significance of this space:

The Cleveland Arcade is a particularly noteworthy example of the skylighted arcade—a building type that is one of the most unique contributions of nineteenth century architecture to the urban scene. Functionally and commercially this prominent Cleveland structure is an arcade, for it provides a passageway between two large urban thoroughfares and it contains many shops and offices related to the individual companies. But its tiers of galleries and dramatic use of interior space make it architecturally more akin to the light courts of the multi-stories commercial structures which were developed before the introduction of sufficiently brilliant interior artificial lighting. In construction the Arcade is mixed in technique and materials and reflects the rapid changes in high buildings in the 1880s and 1890s—an era that saw the birth of the skyscraper.

It's worth noting that HABS also has extensive documentation and architectural drawings of the building.

If you haven't been in a while, stop in the next time that you are in downtown Cleveland. If you go through it every day, slow down a little to

enjoy it. There have been problems with occupancy. I don't know what is the best use for this space—most stores need more space than can be provided by the small jewel-like storefronts of the Arcade. Whatever this space is used for in the future, it should invite public access.

The Arcade is the most architecturally significant building in Cleveland. It houses an incredible interior space. Let's find some way to use it wisely.

STREAMLINED

When it was completed in August 1940, the Cleveland Coast Guard Station was considered to be the "most beautiful in the nation." The architect was J. Milton Dyer, also known for his Brown Hoist building (see "The Brown Hoist Building: An Industrial Landmark"), Cleveland Athletic Club, Cleveland City Hall, First Methodist Church (East Thirtieth and Euclid), Peerless Motor Car Company (later the Carling Brewery; see "Cars, Beer and the Law") and Tavern Club.

The complex was built on fill at the end of a long pier just off the end of Whiskey Island at a cost of $360,000 ($5.5 million in 2010 dollars). The main building contained quarters for officers, crew and staff; a communications room; a recreation room; a mess hall; and storage. The boathouse has slips for three vessels. Even in their current deteriorated condition, it is an extraordinary group of buildings.

All of the buildings originally had steel casement windows, some square and some that curved with the wall. The staircase to the second floor continues the "streamlined" elements present in the rest of the building. The windows on the corner of the main building illuminated the interior space, as well as softening the relationship between the main structure and the garage. The patio provided a lovely place to sit, observing the city and harbor.

The location is beautiful. If the building is reopened, the observation tower would provide wonderful views.

Given the condition of the building, what should be done now? It would cost $5 million or more to restore the buildings, and it seems unlikely to find sources of public or private funds.

Perhaps it's best to keep the building stabilized as a ruin, preserving the visual character without the cost of a restoration. Reuse is not the only option that we have to preserve our landmarks. But still, the building still requires some commitment. All parts of the roof must be repaired to

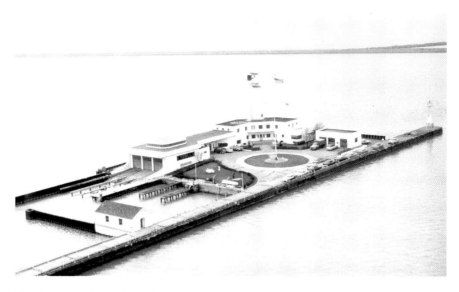

The Cleveland Coast Guard Station (1940), J. Milton Dyer, architect. *Courtesy of the United States Coast Guard, February 15, 1951.*

prevent further structural damage. Exposed steel needs to be painted to prevent further rust.

These historic buildings are located at Wendy Park at the mouth of the Cuyahoga River, a beautiful area in the heart of the city.

OLD HOUSE, OLDER HOUSE?

I came across an Italianate house at 6512 Superior Avenue in Cleveland while on my ongoing quest to document all of the Greek Revival houses still extant in the city. Online, the Pictometry bird's-eye view of the house was promising—the proportions of the roof on the rear wing of the house looked just right. Further, I've seen several houses where an Italianate addition was built in front of an earlier Greek Revival structure—the funeral home at the corner of East Eighty-ninth and Cedar is a good example. The Cozad-Bates house is another.

The overall quality of this house, from what can be seen on the exterior, is excellent. Note the trompe-l'œil painting of stone. Someone has clearly put a lot of energy into this house, up until recently. The house has a very nice presence: the columns on the front porch are impressive, and the complex moldings around the windows frame them beautifully.

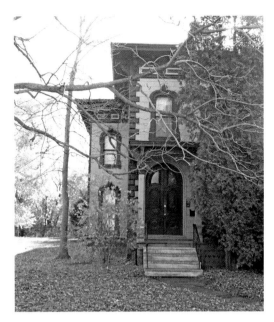

Frame Italianate-style house (circa 1880), 6512 Superior Avenue, Cleveland, Ohio. *Photograph by the author, November 6, 2009.*

The east side of the house shows transitions between an older and newer structure. Since the foundation on the older part extends under the Italianate part, this suggests that part of the front of the older part was removed when the house was expanded.

The west side of the house presents a clear break between the two wings. The foundation changes abruptly between the two halves.

The biggest problem I have with describing the older part of the house as Greek Revival are the size and proportions of the windows. For a Greek Revival, I would have expected smaller, skinnier windows. Of course, the windows could easily have been replaced at sometime in the past—perhaps at the same time the house was expanded.

I have a hard time placing an exact date on this house. The tooling of the stone used for the foundation on the older part of the house is consistent with what I've seen used in houses dating from the 1830s to 1850s. The Italianate style, used for the main part of the house, was popular from the 1840s to the 1880s. I'm not familiar enough with the style to provide a more precise date. I consulted the Hopkins 1881 *Atlas of Cleveland*, which illustrates the location of each individual house. This house was not included. I'm beginning to doubt the completeness of that atlas, as there are several houses I've come across recently that I would have expected to be included but are not.

According to the county auditor, the house is 3,400 square feet, on a lot measuring 8,850 square feet. This is the best frame Italianate I've yet seen in Cleveland. While it needs paint, and probably a new roof, it seems to be in quite good condition.

I was browsing Charles Whittlesey's *Early History of Cleveland, Ohio* when I came across a map illustrating an "Ancient Fort" in Newburg Township. I've always been interested in the prehistory of this area and was excited about the possibility of finding an ancient earthen structure inside the city.

Whittlesey provided a great description of the location:

> *This consists of a double line of breast works with ditches across the narrow part of a peninsula between two gullies situated about three miles south easterly from the city on the right of the road to Newburg on land heretofore owned by the late Dr. H.A. Ackley. The position thus protected against an assault is a very strong one where the attacking party should not have projectiles of long range.*
>
> *On three sides of this promontory the land is abrupt and slippery. It is very difficult of ascent even without artificial obstructions. Across the ravine on all sides the land is upon a level with the enclosed space. The depth of the gully is from fifty to seventy feet. About eighty rods to the east upon the level plain is a mound ten feet high and sixty feet in diameter. At the west end of the inner wall is a place for a gateway or passage to the interior.*
>
> *The height of the embankment across the neck is two feet and the enclosed area contains about five acres. Perpetual springs of water issue from the sides of the ravine at the surface of the blue clay as they do at Cleveland.*

I began by checking the 1858 Hopkins map, on which I was excited to see land owned by Dr. Horace A. Ackley was located south of Broadway, between East Fifty-fifth and East Sixty-fifth Streets. That this land is the right spot is confirmed by the presence of streets named "Ackley" and "Mound."

The problem is that the landscape shown in Whittlesey does not correspond at all with what is present today. The stream shown in the picture, Morgan Run, has been culverted and the gullies bulldozed flat. I thought perhaps that another historic atlas might show the location of the stream, which could give me a starting point. The 1881 *City*

"Ancient Fort," Newburg. Image from Charles Whittlesey's *Early History Cleveland, Ohio*, courtesy of Special Collections, Cleveland Public Library. *Map by Audrey Busta-Peck.*

Atlas of Cleveland, Ohio shows a stream that isn't a perfect match, but it's a reasonable approximation.

I still wanted to correlate the historic geology with modern roads. A partial solution was found in a turn-of-the-century United States Geological Survey (USGS) topographical map, which gave me some idea. I visited the area, looking for anything that might look even faintly moundlike, but there seems to remain no physical evidence of either the defensive mounds or the circular one to the east.

Part VII

Lost and Threatened

Threatened: The Euclid Avenue Church of God

A Cleveland Landmark, the Euclid Avenue Church of God at 8601 Euclid Avenue might be demolished. The congregation has received an offer from the Cleveland Clinic.

The church, originally the Reformed Episcopal Church of the Epiphany, was designed in 1889 by Sidney Badgley, architect of many significant churches in Cleveland and elsewhere. It was built by Thomas Hamilton at a cost of $14,000 and was dedicated on June 1, 1890. It was said to be the first Reformed Episcopal church in Ohio.[99]

Part of what makes the structure significant is its relationship to its next-door neighbor, the Francis Drury mansion. In a review of the architect's work, it was noted that "[o]ther Cleveland churches of Mr. Badgley's design are the Church of the Epiphany, on Euclid Avenue, where the problem of building on a lot only 45 feet wide was successfully met."[100]

The Drury mansion, at 8615 Euclid Avenue, was built in 1910–12. It was designed by Meade & Hamilton, architects, and is one of but a handful of remaining houses built on what was once a boulevard of magnificent homes. The prestige of a Euclid Avenue address seems to have been more important to the Drurys than the proximity of the adjacent church.

The interior of the church is just as impressive as the exterior. It features beautiful woodwork, especially on the ceiling, as well as a sanctuary that is lined with stained-glass windows.

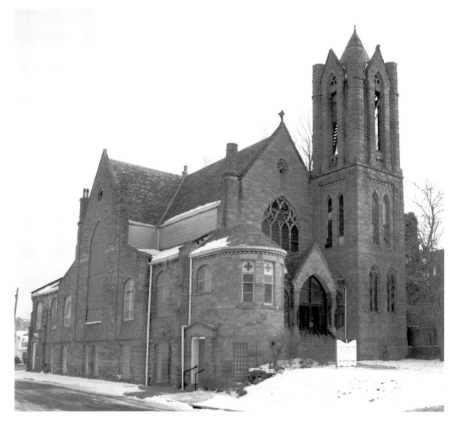

Euclid Avenue Church of God (1890), Sidney Badgley, architect, 8601 Euclid Avenue, Cleveland, Ohio. *Photograph by the author, February 23, 2011.*

It's a beautiful building, one that would be difficult to argue in favor of demolishing. Yes, it needs work, but that's what happens when maintenance is deferred.

It's not enough for us now to merely "care" about the fate of these historic structures—we must make up for our years of neglect. The arrangement between Temple Tifereth-Israel and CWRU[101] is an example of a successful project.

In addition to the beauty of this building, it is important as a fragment of the history of Euclid Avenue and the context it provides. With its demolition, the Francis Drury mansion will lose a significant bit of context—and the city, a significant landmark.

The Last Act for Johnson's Cleveland Play House

The Cleveland Clinic has purchased the Cleveland Play House complex, including the spectacular building built in 1983 by Cleveland native Philip Johnson. Johnson, one of the most significant architects of the twentieth century, is best known for his 1949 Glass House, a National Historic Landmark, in New Canaan, Connecticut. Johnson's playful postmodern approach to Romanesque styling is as theatrical as it is delightful. Johnson's addition embraced and unified existing structures, including two existing theaters and a Sears Department Store building. The playhouse is the only building in Cleveland that was designed by Johnson, and it is moving to downtown Cleveland.

If the Cleveland Clinic follows the path it has in the past, this building will be demolished. While the clinic has not been public about its plans for the property, I believe that administrators can find a way to utilize the buildings with little modification. Two-thirds of the playhouse property is surface parking now. Surely the clinic's need for room to expand could be satisfied by efficient use of the land that is currently asphalt lots.

Cleveland Play House (1983), Philip Johnson, architect, 8500 Euclid Avenue, Cleveland, Ohio. *Photograph by the author, June 29, 2011.*

SAVING ONLY THE BELL

The Euclid Avenue Congregational Church, at 9606 Euclid, was the victim of a fire caused by lightning in the early hours of Tuesday morning, March 23, 2010. The church was built in 1884–87 by Coburn and Barnum, an architectural firm responsible for many of the great Euclid Avenue homes. The building was a Cleveland Landmark. Demolition began within hours.

Euclid Avenue Congregational Church (1887), Coburn and Barnum, architects, 9606 Euclid Avenue, Cleveland, Ohio. Destroyed by lightning-caused fire, March 23, 2010. *Photograph by the author, March 23, 2010.*

The *Church Building Quarterly* in 1888 described the construction:

> This building, shown in the illustration, is built of "Amherst" Ohio sandstone. The stone is quarry faced, except some of the trimmings, which are tooled. The roofs of the towers are tooled stone. The brick from the old church building, which occupied the same site, was used for backing. The main tower is ninety-eight feet high.
>
> The two towers form vestibules, opening into the main auditorium, which is very cheerfully and effectively decorated, and will seat one thousand people. The windows are opalescent glass, beautifully designed. The walls are painted in oil, with clouded effects, shaded lighter from the floor up. The entire woodwork is antique oak, plain and solid. The prevailing colors in the church are light olive and terra-cotta. The acoustic properties are perfect.
>
> The re-building of the church, using old material where possible, cost $35,000; but it could not be built again for that amount. The total value of the property, including lot, chapel, and parsonage, which adjoins the chapel, is estimated at $100,000.

The church had been well maintained.

Demolition began shortly after the fire was put out. By 1:00 p.m. on Tuesday, considerable progress had already been made. By 6:00 p.m., a substantial amount of the church was gone. Much of the wall closest to the Cleveland Clinic was already lost. Smoke (or dust) was coming from the ruins.

A bell, used in each of the three buildings occupied by this congregation, was salvaged. A pile of steel I-beams, likely bound for the recycler, was separated from the rest of the debris. The remainder of the stone, brick and other material was loaded into dumpsters, probably bound for fill.

It seems wrong that the building was demolished so quickly. While I understand that the building was beyond the point of repair and that there were serious public safety concerns, I have to wonder if there wasn't some way that pedestrians could have been protected from the potential of falling debris while the situation was given some thought.

Even as a burned-out shell, it was an impressive structure. Could some part of it have been stabilized as a ruin, as has been done with so many historic European churches? The tower of St. Agnes Church, just down the street, was saved, and that remains a landmark in the community.

THE PRINCE HALL MASONIC LODGE ON EAST FIFTY-FIFTH STREET

The brick Masonic Hall at 1624 East Fifty-fifth Street in Cleveland was destroyed by fire on May 19, 2010. It was a Cleveland Landmark. Demolition began the following day. According to a *Plain Dealer* article, the fire was ruled as arson.

The hall was built 1907 as the Pythian Castle and was designed by architect Frederic William Striebinger. Another notable building by Striebinger is the Second Church of Christ, Scientist (now True Holiness Temple) at 7710 Euclid Avenue.

It served as a B'nai B'rith lodge from 1912 through the 1940s.

Pythian Castle/Prince Hall Masonic Temple (1907), Frederic William Striebinger, architect, 1624 East Fifty-fifth Street, Cleveland, Ohio. Destroyed by arson, May 19, 2010. *Photograph by the author, April 21, 2010.*

GOOD HOMES MAKE GOOD NEIGHBORHOODS

I stopped to photograph this house at 2200 East Sixty-ninth Street in April 2009 when I saw the "condemned" notice attached near the front door. It's located in the Fairfax neighborhood of Cleveland. By June 2011, the house was gone.

Simple house (circa 1880), 2200 East Sixty-ninth Street, Cleveland, Ohio. Demolished. *Photograph by the author, April 12, 2009.*

It retained most of the original features: the windows on the front of the house with the rounded tops; the stained glass one on the side, probably on the stairs to the second floor; and the interesting detail on the porch. The proportions of the house as a whole were just right. It just seemed so comfortable on the lot, like it really ought to have stayed.

We should be thinking about fixing up houses like this. Well-proportioned structures with good bones that are relatively unaltered—these are the best buildings that make up our neighborhoods. They're the ones that we need to protect.

Charles Schweinfurth's Modest House

Charles Schweinfurth was the most important individual architect in Cleveland in the 1880s and 1890s and through to the turn of the century. Among his notable commissions are the Union Club, the Cuyahoga County Courthouse, the beautiful bridges over Martin Luther King Jr. Boulevard, Trinity Cathedral, the Samuel Mather residence and his own house.

So it caught my attention when I saw an item on the Cleveland Landmarks Commission agenda for demolition of an 1883 house by Schweinfurth at 1208 Kenilworth Avenue, in Tremont. Of the thirty houses he designed in Cleveland, this is one of only six that remain. It is known as the Henry C. Holt residence, after the man who commissioned it.

The house is owned by the Ukrainian Museum-Archive, which had purchased the house a few months earlier. The museum is housed and operated in the house and building on the adjoining property, 1202 Kenilworth. The museum wants to demolish the house so that it can use the land for surface parking. With the landscaping that it shows in its plan, demolition of the house would create twenty-one parking spaces.

The house was bit worse for the wear on the outside—a conversion into a business left an insensitive brick addition on the front, encompassing the porch. The massive chimney, which provided visual balance, was also gone. It is hard to imagine as it once appeared.

When I saw photographs of the interior of the house, I was not quite sure how to respond. It was difficult to believe how little of the original fabric of the house remained.

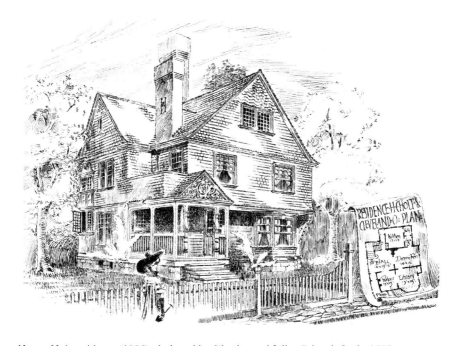

Henry Holt residence (1883), designed by Charles and Julius Schweinfurth, 1208 Kenilworth Avenue, Cleveland, Ohio. Illustration from *Building*, June 1884. *Courtesy of Special Collections, Cleveland Public Library.*

As demolition of the house was discussed by the Landmarks Commission, two images of the house—an illustration from a magazine that was contemporary with the construction of the house[102] and a 1954 photograph—were used to discuss the original appearance. Some suggested that the photograph more accurately represents the house as built than the 1884 illustration. I believe otherwise. An image from the May 10, 1895 *Plain Dealer* shows a second-floor porch, as in the illustration, which was gone by 1954. It also shows the first-floor porch in its original form, confirmed by an 1896 Sanborn Fire Insurance Map. The 1913 Sanborn map shows the expanded porch.

The Richard T. Coleman residence and the Henry C. Holt residence are good subjects for comparison. We can guess what the Holt house looked like from what the interior of the Coleman house looks like today. The Holt residence was designed by Charles and Julius Schweinfurth in 1883 and built at a cost of $5,000. The Coleman residence was built by Charles Schweinfurth in 1889 at a cost of $6,000. The Coleman residence is a bit larger than the Holt residence, so the construction cost per square foot (and finish quality) for the Holt residence was higher. In comparison, the Sylvester Everett residence, an 1883 Schweinfurth commission (now demolished), cost $200,000.

The illustration in *Building* shows, through the porch, the top half of the front door. It appears identical to the front door on the J.R. Owens residence, another house designed by Schweinfurth, at 1956 East Seventy-fifth Street. The set of classically detailed windows to the rear of the house provided natural light on the ornate woodwork that enclosed the stairs. The floor plan in *Building* can help us to make some guesses as to how the interior of the house might have appeared. There are three fireplaces on the first floor, just as in the Coleman residence. The front door of the Holt house led into a small entryway and another door. It might well have been something as impressive as the Dutch door in the Coleman residence. The main hall featured a grand staircase, perhaps similar to the extraordinary staircase in Coleman's.

That's all we have—images of the interior of the Coleman house and guesses that the Holt residence was similar. I don't know what to say at this point.

A House in a Community

Henry Clay Holt was born in Southington, Connecticut, in 1853, the second child of Hiram and Alvira Holt. The Holts were farmers in Harwinton, in northwest Connecticut, in 1860. They had sufficient means to employ a servant.[103] Ella Mary Holt was born on October 4, 1856, in Chagrin Falls, Ohio.

By 1880, Henry had married Ella Mary and was living in Cleveland at 71 Jennings Avenue (now 2121 West Fourteenth Street). Henry was employed as a bookkeeper. The Holts had a daughter, Clara H. Holt, born in October 1879. They employed a servant and also had a boarder, who was also a bookkeeper.[104] A son, John W. Holt, was born in February 1886.

H.C. Holt began working as a secretary at Lamson and Sessions before 1882; he is listed as a pallbearer in the funeral of Thomas H. Lawson, one of the founders of the company.[105] An 1895 ad lists him as one of the corporate officers at the time the company was incorporated in 1883.[106] Lamson and Sessions, a manufacturer, is still headquartered in the Cleveland area.

In 1883 or 1884, the Holt family moved into 94 Kenilworth Street (the address changed in 1905 to 1208), designed by Julius and Charles Schweinfurth. The Lamson and Sessions factory, and presumably its corporate offices, were located close to the house on Kenilworth—less than half a mile away.

A brief mention of the commission for the house is given in the *American Architect and Building News* of November 24, 1883, noting simply: "Residence for W.O.B. Skinner and Mr. H.C. Holt, to cost, $9,000 and $5,000 respectively, are to be built from the designs of Messrs. C.F. & J.A. Schweinfurth." Schweinfurth's commission of the Sylvester T. Everett residence, at 4111 Euclid Avenue, is noted on the same page, with a cost of $200,000. The Holt residence may well be the least expensive house Schweinfurth ever created.

Henry Holt was active in his community. The Holt family were members of Pilgrim Congregational Church, at the corner of West Fourteenth Street and Starkweather Avenue. Henry served as treasurer there for a time. He was a member of the Congregational Club.[107] He was also a member of the Ohio Society, Sons of the American Revolution. That organization's 1897 yearbook lists him as the "[g]reat-grandson of Reuben Hart, who was Ensign of 3d Company Alarm Lists, 15th Connecticut Regiment, 1777; Captain's Commission, dated May 28, 1778, signed by Jonathan Trumbull, Governor." Ella Holt is listed frequently in the society pages of the *Plain Dealer*, though, as was the custom at the time, as Mrs. Henry C. Holt.

As of 1900, Henry C. Holt had left Lamson and Sessions and was employed as a secretary by National Bolt Works.[108] He continued to work as a secretary in the manufacturing industry for the rest of his life.[109]

Henry and Ella Holt signed papers transferring the house on Kenilworth to the Ukrainian Greek Catholic Diocese on July 16, 1920. The transfer was recorded on November 20 of that year. Henry C. Holt died on November 23, 1920. His funeral was at Pilgrim Congregational Church.

In 1924, Ella Holt, at the time a resident of 1929 East Ninetieth Street, applied for a passport. She stated that she intended to depart on January 16, 1924, and visit the British Isles, France, Egypt, Italy, Greece, Switzerland, Algiers, Monaco, Palestine, Gibraltar, Holland, Belgium and Spain. She returned to the United States on April 8, 1924, on the *Olympic*. She intended to travel further, as she renewed her passport on December 12, 1924, for an additional year.

The house appears to have been used by the Sisters of St. Basil as a convent from 1920 to 1936. They operated the house next door, 1202 Kenilworth, now the Ukrainian Museum-Archives, as an orphanage. Beginning in 1938, the residence was used as a day-care center as part of Tremont Center, a comprehensive social service bureau, which also occupied 2337 West Fourteenth Street (now demolished).[110] The center, known as Merrick House Day Care, operated on the premises until at least 1942.[111]

The property was transferred from the Ukrainian Greek Catholic Church to Paul and Anna Holowczak for $15,000 in 1955.[112] Paul Holowczak was born in Galicia, an area of Ukraine, in 1894. He immigrated to the United States in 1904. As of 1920, he worked as a laborer in a furnace.[113] His first language was either Russian [114] or Ukrainian.[115]

Anna Pelechaty was born in 1906 in Winnipeg, Manitoba. She was the youngest of four children and the only daughter of Wojeicek and Mary Pelechaty. Wojeicek Pelechaty was a carpenter. He and Mary immigrated to Canada in 1899 from Galicia.[116]

By 1930, Paul owned a house at 2387 Professor Avenue in Tremont. He used this as a funeral home, his own residence and as a rental property.[117]

Paul Holowczak and Anna Pelechaty married sometime between 1930 (when Paul is listed in the census as single) and 1936, when their first child, Paul Jr., was born. They had two more children, Peter and Joseph.

Paul Holowczak used 1208 Kenilworth as a funeral home and residence beginning in 1955. Paul Holowczak died in 1961. His funeral was held at SS. Peter and Paul Ukrainian Catholic Church. He was buried at SS. Peter and Paul Cemetery in Parma.[118]

Anna Holowczak continued to operate the business, presumably with the help of her sons. She died on June 13, 1985. Her funeral was held at the Holowchak Funeral Home on State Road, in Parma. I don't know when Holowczak Funeral Home in Tremont closed or how long it has sat empty. Peter and Joseph Holowczak sold the house to the Ukrainian Museum-Archives in 2009.

The house at 1208 Kenilworth has had an interesting history. It has played a vital role in its community. For almost forty years, it was home to a single

family. Then it served as a convent for about eighteen years. Next the house was transformed into a day-care center, surely creating fond memories for many children. Finally, it became a funeral home and residence, for years providing a place for people to mourn their losses.

It has been demolished and is now a gravel parking lot.

TROUBLING NEWS

In 1911, James H. Foster purchased land in the Ambler Heights neighborhood of Cleveland Heights and hired architects Walker and Weeks to design a house for him and his bride of four years. He was thirty-two and already a top executive in the steel industry. Walker and Weeks was Cleveland's most prestigious firm.

In January 2011, Chuck Miller reported in the *Heights Observer* on troubling news regarding the fate of the house built for James and Edith Foster. The new owners of the house at 2200 Devonshire Drive, Steven E. Nissen and Linda R. Butler, planned to demolish the house in favor of a smaller, "greener" structure. The house was the oldest extant house designed by Walker and Weeks. It was listed in the National Register of Historic Places as a contributing structure in the Ambler Heights Historic District.

No less an authority on Cleveland architecture than Eric Johannesen, in *A Cleveland Legacy*, wrote, "Another class of residences was somewhat larger

James H. Foster residence (1911), Walker and Weeks, architects, 2200 Devonshire Drive, in the Ambler Heights Historic District of Cleveland Heights, Ohio. Demolished. *Photograph by the author, February 7, 2011.*

and was characterized by a more emphatic, not to say massive, hip roof that was brought down over a porch in the contemporary bungalow fashion." Johannesen continued, "The finest of these was the stucco house built for James H. Foster on Devonshire Drive in Ambler Heights, and its form could be seen as a direct reference to the work of contemporary English architect C.F.A. Voysey, who was working in a revival of a country vernacular idiom."

This is not the sort of house that is usually threatened with demolition in Cleveland, particularly in a prosperous neighborhood. The house had been vacant for a number of years—and showed it—but all things considered, it was not only livable but also worth the expense of updates for its next hundred years.

The interior photographs of the house, taken when the house was listed for sale, show living space that is phenomenal—the very best work and finish that one will find of its era. The 8,500-square-foot house was sited on a 1.15-acre lot and boasted six bedrooms and six baths.

Describing a debutante party for Mary Stanley Foster, one of the Foster daughters, Cornelia Curtis reported that "[t]he Foster home with its spacious rooms and broad verandas was a profusion of flowers, gift bouquets sent to the debutante, which were placed on tables and banked on the fireplace mantles. There are two large living rooms at the north end of the entrance hall, and in the second, several steps lower than the first floor, Mrs. Foster received the tea."

She continued: "The guests enjoyed the garden, and spacious verandas with their attractive summer furnishings…The floor of the tent in one corner was cut away to reveal the circular lily pond with its bronze fountain figure. In the pond were colored lilies…From the tent could be seen the swimming pool in the center of the formal garden which yesterday was like a great turquoise in a green setting."[119]

The City of Cleveland Heights lacks the legal power to prevent demolition. But there is no good justification for demolition of this house. This house is a significant part of the history of the neighborhood and the city in which it was built.

It's been said time and again that the greenest structure is the one that's already built. It would be better to keep this house than to discard all of the built energy and history it contains.

Fortunes and Families

James H. Foster purchased the land that is the site for this house in 1911 from Elizabeth S. Caswell and Martha B. Ambler.[120] He hired Walker and Weeks to design the house, which was completed in 1911 or 1912.

Samuel Orth, in his *History of Cleveland, Ohio*, described Mr. Foster:

James H. Foster, whose relation to the public interests of Cleveland is that of vice president and general manager of the Hydraulic Pressed Steel Company, is contributing through his activity in this field to the business enterprise that has led to the growth of the city and given it rank with the ten largest cities of the Union.

James H. Foster was born in Meriden, Connecticut, April 10, 1879. Pursuing a course in St. Paul's school at Concord, New Hampshire, he thus prepared for collegiate work, which he received in Yale University and Williams College, being graduated from the latter with the degree of Bachelor of Arts as a member of the class of 1900. Thus equipped by liberal education for a business career, he turned his attention to real-estate operations in Pittsburg, Pennsylvania, where he continued for one year. During the succeeding three years he was connected with the American Tubular Wheel Company and in 1904 came to Cleveland, entering into active association with the firm of Parish & Bingham in the capacity of assistant general manager. He thus served until August, 1906, when he organized the Hydraulic Pressed Steel Company, with a capital of one hundred and fifty thousand dollars, and was elected vice president and general manager. From a modest beginning the business has advanced by leaps and bounds until it is the largest institution of its kind in Cleveland, doing a business of one million dollars annually. The plant covers six acres and its capacity is being doubled yearly. Several of the most powerful presses ever constructed are in use in this plant, the largest striking a blow of eight thousand tons at the rate of eight strokes per minute. Their product finds ready market in every section of the United States and the export business is continually increasing. Mr. Foster has contributed in substantial measure to the development of this concern, having knowledge and business experience which have constituted a safe foundation on which to build the success of the enterprise. On the 28th of September, 1907, occurred the marriage of Mr. Foster and Miss Edith A. Mcintosh, a daughter of George T. and Elizabeth (Ellis) McIntosh, of Cleveland…Their home, at No. 1932 East Seventy-First street, is the abode of a warm-hearted and generous hospitality. Mr. and Mrs. Foster are members of the Emmanuel church and in church and charitable work Mrs. Foster takes active and helpful part…His leisure hours are devoted to golf, tennis, baseball and various outdoor athletic sports. Pleasure, however, is always the secondary consideration to business with him and his success in manufacturing circles

is due to an unlimited capacity for hard work, splendid executive ability and the faculty of enlisting the support and cooperation of strong business men in his projects.

By 1918, he was president of the Hydraulic Pressed Steel Company of Cleveland, described in *A History of Cleveland and Its Environs* as

an industry with a history of more than ten years of prosperous growth and now without question one of the leading concerns in contributing to Cleveland's greatness as a center of the iron and steel industry.

Mr. Foster learned the steel business through a rigorous apprenticeship. His first experience was in the Pittsburgh district, where he worked for the steel mills at any post of service which his superiors saw fit to assign him. He began there in 1900, fresh from a college career…

After his three years of apprenticeship in the iron and steel district around Pittsburgh, Mr. Foster came to Cleveland and found a position with the Parish & Bingham Company in their sheet metal stamping works. In a short time he was manager of this plant and filled that position until 1906.

In that year he was instrumental in organizing and incorporating the Hydraulic Pressed Steel Company. The first officers of this organization were: A.W. Elleuberger, president; Mr. Foster vice president and general manager; and H.F. Pattee, secretary and treasurer. The plant was ready for operation in 1907. It then contained 20,000 square feet of floor space. The plants now include a steel plant of four open-hearth furnaces, rolling mills, sheet mills, etc., located at Canton, Ohio, and two fabricating plants in Cleveland. These plants occupy 133 acres of land, have an aggregate capital of over $12,000,000 and employ about 5,000 men. The present officers are: A.W. Elleuberger, chairman of the board; J.H. Foster, president; Ernest E. Bell, vice president and director of sales; R.R. Freer, vice president and comptroller; R.D. Mock, treasurer; H.F. Pattee, secretary.

Mr. Foster is a member of the Union Club, Country Club, Mayfield Club, Roadside Country Club and Hermit Club. Politically he does his voting according to the dictates of an independent judgment. In Cleveland, September 28, 1907, he married Miss Edith McIntosh. They have four children: George, aged nine; Mary Stanley, aged seven; James H., Jr., aged five; and Elizabeth McIntosh, aged three. George is a pupil in the Hawkins School for Boys, while Mary Stanley attends the Laurel School for Girls.

The Fosters lived in the house until 1936, when it was transferred (possibly the result of foreclosure) to the Guardian Trust Company.[121] The Guardian Trust Company, in 1945, sold the house to Emmie E. and Harvey B. Brackenridge.[122] They, in turn, sold the house in 1951 to Dr. John M. Wittenbrook and Genevieve Wittenbrook.[123]

Dr. John M. Wittenbrook, a psychiatrist, and Genevieve Wittenbrook raised a large family in this house.[124] Dr. Wittenbrook died in 1972.[125] In 1973, Genevieve Wittenbrook sold the house to George H. and Karole V. Baird.[126]

George H. Baird was the former research head of Shaker Heights schools and founder of Educational Research Council of Greater Cleveland.[127] He died in 1997.[128]

Kirk S. Ramsey, trustee of the Karole V. Baird Trust, sold the house to Steven E. Nissen and Linda R. Butler in December 2010.[129] Dr. Nissen is chairman of the Robert and Suzanne Tomsich Department of Cardiovascular Medicine at the Cleveland Clinic. He was named one of *Time* magazine's 100 Most Influential People in 2007. Linda Butler is a photographer whose work earned her the Cleveland Arts Prize in the visual arts in 1999.

The relatively long tenures of the residents of this house are part of what kept it in good condition. All of the evidence that I've seen suggests that this house was quite habitable.

However, the house has been demolished. Some garden structures are being preserved.

NOTES

PART I

1. Cuyahoga County Recorder, AFN: 183605040001.
2. *Annals of the Early Settlers Association*, no. 4, 47.
3. *Annals of the Early Settlers Association*, no. 11, 465–66.
4. The 1850 and 1860 censuses.
5. From a grave marker at Harvard Grove Cemetery.
6. The 1850 census.
7. Cuyahoga County Recorder, AFN: 182603220001.
8. Cuyahoga County Recorder, AFN: 183404050001.
9. Cuyahoga County Recorder, AFN: 200602230712.
10. Daughters of the American Revolution, Lakewood Chapter, *Early Days of Lakewood* (Lakewood, OH: self-published, 1936); Margaret Manor Butler, *The Lakewood Story* (New York: Stratford House, 1949); "Warren Family" from *Mrs. Townsend's Scrap Book*, 9, found online in the Local History Files at Lakewood Public Library, http://www.lkwdpl.org/history/9biographyS-Z.htm#0:22.
11. Cuyahoga County Recorder, AFN: 182406250001.
12. Thea Gallo Becker, *Lakewood* (Charleston, SC: Arcadia, 2003), 10.
13. Cuyahoga County Recorder, AFN: 184003030002.
14. Historic American Buildings Survey, *Warren House, Warren & Fisher Roads, Lakewood, Cuyahoga, OH*, "Documentation," page 5; the 1850 census.
15. Cuyahoga County Recorder, AFN: 185304160001.
16. Cuyahoga County Recorder, AFN: 190405130005.
17. Cuyahoga County Recorder, AFN: 193603230012.
18. Cuyahoga County Recorder, AFN: 193803100082.

19. Cuyahoga County Recorder, AFN: 193806040032.

20. Cuyahoga County Recorder, AFN: 183304160003.

21. Cuyahoga County Recorder, AFN: 183510080009.

22. Cuyahoga County Recorder, AFN: 183111170002.

23. *History of Sangamon County, Illinois* (Chicago, IL: Inter-state Publishing, 1881), 728.

24. Cuyahoga County Recorder, AFN: 183909160004.

25. Cuyahoga County Recorder, AFN: 183702010001.

26. Cuyahoga County Recorder, AFN: 183909170001.

27. Cuyahoga County Recorder, AFN: 185403230004.

28. Cuyahoga County Recorder, AFN: 185404140009.

29. Cuyahoga County Recorder, AFN: 187404040019.

30. The 1850 census; Cuyahoga County Recorder, AFN: 184211100007.

31. *Annual Report, Cleveland Hospital for the Insane* (Columbus, OH: Nevins & Myers, State Printers, 1878), 52, 61–62 and 66.

32. *Annual Report, Cleveland Hospital for the Insane* (Columbus, OH: Nevins & Myers, State Printers, 1879), 58.

33. Cuyahoga County Recorder, AFN: 189402030016.

34. Cuyahoga County Recorder, AFN: 190307090051.

35. Cuyahoga County Recorder, AFN: 190307080006.

36. Cuyahoga County Recorder, AFN: 190804290018.

37. Cuyahoga County Recorder, AFN: 194609070013.

38. Cuyahoga County Recorder, AFN: 191504140123.

39. Ibid.

40. Cuyahoga County Recorder, AFN: 194609070013.

41. Cuyahoga County Recorder, AFN: 194703070071.

42. Cuyahoga County Recorder, AFN: 196408120074.

43. Cuyahoga County Recorder, AFN: 00938852.

44. Cuyahoga County Recorder, AFN: 200011090911.

45. Ibid.

PART II

46. Clay Herrick, *Cleveland Landmarks* (Cleveland, OH: Cleveland Landmarks Commission, 1986), 160.

47. *Plain Dealer*, June 14, 1877, 4.

48. *Plain Dealer*, March 9, 1878, 4.

49. *Plain Dealer*, December 9, 1882, 8.

50. *Plain Dealer*, December 12, 1884, 4.

51. *Plain Dealer*, September 20, 1880, 4.

52. *Plain Dealer*, September 29, 1890, 5.

53. *Plain Dealer*, October 15, 1878, 1.

54. *Plain Dealer*, November 11, 1880, 4.

55. *Plain Dealer*, December 6, 1880, 4.
56. *Plain Dealer*, October 5, 1884, 4.
57. *Plain Dealer*, February 13, 1887, 5.
58. *Plain Dealer*, August 6, 1888, 8.
59. *Plain Dealer*, April 29, 1889, 8.
60. *Plain Dealer*, June 17, 1890, 8.
61. *Plain Dealer*, July 1, 1890, 2; and July 8, 1890, 6.
62. *Plain Dealer*, February 17, 1891, 8.
63. *Plain Dealer*, February 7, 1891, 3.
64. *Plain Dealer*, August 31, 1890, 3; February 13, 1891, 5; and April 16, 1891, 8.
65. *Plain Dealer*, December 18, 1890, 4.
66. *Plain Dealer*, March 15, 1891, 3.
67. *Plain Dealer*, April 6, 1891, 2.
68. Ibid., 8.
69. *Plain Dealer*, May 21, 1891, 6; and July 21, 1893, 8.
70. *Plain Dealer*, October 9, 1891, 8.
71. *Plain Dealer*, December 14, 1894, 5.
72. *Plain Dealer*, May 16, 1893, 2.
73. *Plain Dealer*, June 13, 1893, 6.
74. *Plain Dealer*, June 15, 1893, 1.
75. *Plain Dealer*, February 1, 1894, 5.
76. *Plain Dealer*, May 8, 1895, 2.
77. *Plain Dealer*, July 14, 1895, 6.
78. *Plain Dealer*, July 20, 1895, 7.
79. *Plain Dealer*, February 27, 1902, 7.
80. *Plain Dealer*, April 5, 1914, 6.
81. *Bankers Magazine* 104, page 608.
82. Cuyahoga County Recorder, AFN: 192206230143.

Part III

83. *Plain Dealer*, November 23, 1907, 12.
84. Cuyahoga County Recorder, AFN: 185101280004 and 187010010001.
85. *Plain Dealer*, November 8, 1952, 23.
86. *Plain Dealer*, October 4, 1954, 28.
87. Cuyahoga County Recorder, AFN: 186605070006.
88. Cuyahoga County Recorder, AFN: 187007120007.
89. *Plain Dealer*, November 23, 1907, 12.
90. Ibid.
91. *Plain Dealer*, January 25, 1901, 2.
92. *Plain Dealer*, March 6, 1901, 6, 10.
93. *Plain Dealer*, May 19, 1901, 18.

94. *Plain Dealer*, November 11, 1901, 8.

95. *Plain Dealer*, May 22, 1902, 14; and October 7, 1903, 2.

96. *Plain Dealer*, June 21, 1902, 3.

97. *Plain Dealer*, July 22, 1949, 24.

98. *Plain Dealer*, September 9, 1931, 11.

PART VII

99. *Plain Dealer*, September 9, 1889, 8; March 31, 1890, 8; May 31, 1890, 2; and June 14, 1890, 7.

100. *Ohio Architect and Builder* (August 1903): 27.

101. *Plain Dealer*, March 19, 2010.

102. *Home*, June 1884.

103. The 1860 census.

104. The 1880 census.

105. *Plain Dealer*, August 21, 1882, 1.

106. *Plain Dealer*, May 10, 1895, 17.

107. *Plain Dealer*, November 17, 1891, 4.

108. The 1900 census.

109. The 1920 census.

110. *Plain Dealer*, March 7, 1938, 13.

111. *Plain Dealer*, August 30, 1942, feature section, 4.

112. Cuyahoga County Recorder, AFN: 195501120055.

113. The 1920 census.

114. Ibid.

115. The 1930 census.

116. The 1916 Canadian census.

117. The 1930 census.

118. *Plain Dealer*, November 22, 1961.

119. *Plain Dealer*, June 18, 1930, 16.

120. Cuyahoga County Recorder, AFN: 191108160057 and 191108160058.

121. Cuyahoga County Recorder, AFN: 193608180078.

122. Cuyahoga County Recorder, AFN: 194511210122.

123. Cuyahoga County Recorder, AFN: 195101100109.

124. *Cleveland Press*, May 31, 1972.

125. *Cleveland Necrology File.*

126. Cuyahoga County Recorder, AFN: 00621483.

127. *Time*, May 30, 1960.

128. *Plain Dealer*, March 26, 1997, B8.

129. Cuyahoga County Recorder, AFN: 201012220312.

About the Author

Christopher Busta-Peck is the founding editor of the Cleveland Area History blog (www.clevelandareahistory.com). By day, he's a children's librarian at the Langston Hughes branch of Cleveland Public Library.

He lives with his wife, Audrey, and children Everett and Delilah, ages three and one, respectively. They live in their dream house: a 1926 Tudor that has been virtually unchanged—even three of the toilets are original! He expects the repairs on the house to keep him busy for the rest of his life.

Among all this, he somehow finds time to write and take photographs. You may have seen him, bounding toward this or that historic structure and then back to his car and on to the next house.

He received a BA in studio art from Hiram College (2003) and a master's in library and information science from Kent State University (2005).

Visit us at
www.historypress.net
..
This title is also available as an e-book